DATE DUE

			PRINTED IN U.S.A.

FATHERS AND CHILDREN

FATHERS
AND CHILDREN
In Literature and Art

EDITED BY CHARLES SULLIVAN

HARRY N. ABRAMS, INC., PUBLISHERS

This book is dedicated

to my fathers

actual and spiritual

with love, gratitude, understanding,

and forgiveness

Editor: Elisa Urbanelli
Designers: Raymond Hooper, Arlene Lee, Dirk Luykx
Text permissions: Neil Ryder Hoos
Photo editor: Catherine Ruello

Library of Congress Cataloging-in-Publication Data
Fathers and children : in literature and art / edited by Charles Sullivan.
p. cm.
Includes index.
ISBN 0–8109–3329–2 (hardcover)
1. Father and child in art. 2. Arts. I. Sullivan, Charles, 1933–
NX652.F36F38 1995
700—dc20 *95–7901*

Printed and bound in Hong Kong

This is a test. It has no correct answer. But please complete the following sentence to the best of your knowledge: *"Two of the most* [fill in the blank] *roles in life are being a child's father and being a father's child."* Choose your answer from the following list:

(a) *difficult,* (b) *easy,*
(c) *satisfying,* (d) *frustrating,*
(e) *frightening,* (f) *reassuring,*
(g) *predictable,* (h) *unpredictable,*
(i) *godlike,* (j) *fiendish,*
(k) *exhausting,* (l) *energizing,*
(m) *educational,* (n) *bewildering,*
(o) *sobering,* (p) *intoxicating,*
(q) *demanding,* (r) *undemanding,*
(s) *painful,* (t) *pleasant,*
(u) *inspiring,* (v) *depressing,*
(w) *all of the above,* (x) *all of the above, and more besides,*
(y) *none of the above,* (z) *some of the above, but which?*

There is no "correct" answer to our test, since life is experienced differently by different people, but there may be no "incorrect" answers either, among the many possibilities you were given. All of them are represented in the contents of this book, as you will see (specific examples can be located in the Index).

Many fathers, including writers and artists, would select (a) *difficult* to describe their experience. Consider, for instance, Gérard David's somber medieval painting *Saint Nicholas Slips a Purse through the Window of an Impoverished Nobleman.* The sleepless father's wish—that the Christmas dreams of his sleeping children might come true—is granted almost at the last minute.

Many children, also, might emphasize the difficulty of their experience. For example, poet LeRoi Jones describes the lonely life of a waterfront boy, walking down to the docks each morning and staring at the empty horizon until the sun rises to embrace him and he can "make believe it is my father."

Some children find it (b) *easy* to get along with their fathers, like Simon Ortiz in "My Father's Song":

> My father had stopped at one point
> to show me an overturned furrow;
> the plowshare had unearthed
> the burrow nest of a mouse
> in the soft moist sand.

And some men find fatherhood altogether too easy—an extreme example being Paul Gauguin, who wrote to a friend: "I shall soon be a father again in Oceanica. Good Heavens, I seem to sow everywhere!" Being a parent without "sowing" seems easy, too, as Flaubert describes the experience of two very unlikely foster fathers in the novel *Bouvard*

and Pécuchet, but we find no descriptions of how easy life is, from a child's standpoint, after being orphaned or adopted.

(c) *Satisfying* is the experience of some fathers and of some children; for example, we can tell how paternally proud was Charles Darwin when his son Horace outdid him in a brief argument about the theory of natural selection. As a child, Susy Clemens was very satisfied to be the daughter of the man we know as Mark Twain:

> He is a very good man, and a very funny one; he *has* got a temper but
> we all of us have in this family. He is the loveliest man I ever saw, or
> ever hope to see, and oh *so* absent minded!

Fatherhood is (d) *frustrating* to some men, including Shakespeare's King Lear (until one of his daughters proves loyal to him), Dickens's businessman Dombey (until his wife gives birth to a son and heir), and the melancholy parent in Turgenev's *Fathers and Sons*:

> For the first time he realised clearly the distance between him and his
> son; he foresaw that every day it would grow wider and wider.

My own poem "Another Kind of Country" describes a situation in which both father and son are frustrated by their distance but unable to close it.

(e) *Frightening* fathers include the brutal coal-miner in D. H. Lawrence's *Sons and Lovers*, whose description matches the powerful photograph by Jerry Uelsmann. Less common are frightening children, such as the legendary Lizzie Borden, who killed both of her parents with an axe.

Fathers are often (f) *reassuring,* either by what they say or by what they do, as Edith Wharton, Clarence Day, and other daughters and sons have described. Reassuring children might include Jack Kerouac, who treated his "shabby" father tenderly at times, and Dylan Thomas, who fortified his father poetically against "the dying of the light."

(g) *Predictable* fatherhood is seen in Robert Hayden's poem "Those Winter Sundays," where a man gets up early every week before church to stoke the furnace and to polish his son's shoes. "What did I know," asks the son in retrospect, "of love's austere and lonely offices?" Events that are predictable to parents can also be predictable to children, of course, as we find in Hemingway's almost ritualistic hiking and hunting stories, and in Neruda's tragic poem about a father who worked on trains.

(h) *Unpredictable* children, like Henry Adams and his siblings, may make things lively for parents, deliberately and with good humor. "Father and mother were about equally helpless," he says. Unpredictability in the child's life, however, is another story, as Mary Ann Larkin illustrates in "Immigrant Daughter's Song," when a family has lost its cultural roots:

> All gone
> changed from a silken spool unwinding
> to rooms of relics and loss
> behind whose locked doors
> I dream
> not daring to wake

The (i) *godlike* father is easily recognized in Käthe Kollwitz's sculpture *Rest in His Hands,* seen here with an excerpt from Mona Simpson's novel *The Lost Father,* absence making the child feel more needy and the missing parent seem more divine. Among other writers, John Lennon has rejected a godlike guise:

> I'm not into putting out an image of this person who knows all
> about children. Nobody knows about children. That's the thing.

The godlike child, a rarer image, is found in W. H. Auden's retelling of the fall of Icarus, the human boy who (urged by his father) tries to fly to the sun and fails, as shown in Brueghel's classic painting.

The opposite of godlike, the (j) *fiendish* father is described by Sylvia Plath as "a bag full of God" who died only to become demonized in her imagination:

> You stand at the blackboard, daddy,
> In the picture I have of you,
> A cleft in your chin instead of your foot
> But no less a devil for that. . . .

Children are rarely shown as fiendish to their fathers, more often as impish or mischievous; Elliott Erwitt's photograph of a model family gone awry is one example.

Ogden Nash humorously shows how (k) *exhausting* would be the life of a possessive father who worries that his baby girl is going to be pursued by the most unworthy boys as she grows up. Altogether serious, however, is Henry James's description of a young woman nearly exhausted by her father's efforts to spare her such a fate. Here a brilliant portrait by William Merritt Chase echoes the mood of the text.

Men may not often find fatherhood (l) *energizing,* but one exception occurs in Christopher Tilghman's short story "In a Father's Place," when the divorced parent realizes that he has been a good father after all: "He could not help the rising tide of joy that was coming to him." As for children, some are clearly full of energy already, but others may get an extra boost from a father's encouragement or simply from his quiet support, as does Stephen Daedalus at the end of Joyce's novel *A Portrait of the Artist as a Young Man.*

Childhood is (m) *educational* in general. Specific examples of noteworthy teaching include Lord Chesterfield's sophisticated letters to his natural son, Ogden Nash's lighthearted suggestions for children wishing to outwit parents, and the art-for-all approach of Robert Coles. Fathers, too, can be educated. Balzac's old character Goriot is one of many fathers who learn from their experience, although the lessons are not necessarily pleasant:

> He saw that his daughters were ashamed of him; that if they loved
> their husbands he made trouble between them and his sons-in-law.
> He was bound to sacrifice himself then.

Some of her childhood's (n) *bewildering* moments are captured in Anne Sexton's poem "The Papa and Mama Dance," which is combined here with Jennifer Bartlett's eerily joyless painting *Five A.M.* Men who find fatherhood (and other experiences)

bewildering include Thurber's father and the slaphappy dad who utters Ring Lardner's classic line, "Shut up he explained."

Fatherhood can be (o) *sobering,* as Donald Hall describes it in the poem "My Son, My Executioner," but childhood may be sober also, as we see in Elinor Wylie's poem about her Puritan ancestors. The poet e. e. cummings shows us how life was (p) *intoxicating* for his father, while the Biblical lessons of the Prodigal Son and his wayward life have been vividly drawn by folk artist Ruby Finch.

(q) *Demanding* experiences are described by F. Scott Fitzgerald, who felt that he had to be a father to his wife as well as to his daughter. In Robert Penn Warren's novel *All the King's Men* we see the kind of father who demands even more from his son than he does from himself. Fathers who are (r) *undemanding* may yet be strong influences and deeply loved. For example, Gwendolyn Brooks writes in remembrance of her deceased father: "He who was Goodness, Gentleness, and Dignity is free."

Fatherhood is (s) *painful* for some, like the ancestors recalled by the poet Brendan Kennelly. Even the attempt to reach out to another person's child can be painful, as Richard Wilbur shows in his poem "Cottage Street, 1953," about the spiritual suffocation of Sylvia Plath and the helplessness that he, like other friends and neighbors, felt.

Childhood is frequently (t) *pleasant,* and sometimes child and father share the same pleasures, as we see in Sandy Felsenthal's photo of a big man and his small daughter riding a tiny motorbike through the perfect meadow. Fathers not surprisingly store away such memories, like Longfellow in his celebrated poem "The Children's Hour."

(u) *Inspiring* experiences come to children in all kinds of ways, as David Bottoms understands when remembering his father's efforts to teach him the "basics" of baseball and of life. And occasionally an adult may be inspired by something a child does or says, for example, in the charming letter by Grace Bedell, a little girl who evidently persuaded the clean-shaven Abraham Lincoln to grow whiskers.

Can fatherhood be (v) *depressing?* Yes, especially with the loss of a child. Samuel Clemens (Mark Twain) was so upset by the death of his daughter Susy that he could think and write only about her. Childhood, similarly, can be depressing with the loss of a parent, or more subtly, as Linda Gregg discovers, in the awareness of losses that parents or grandparents may have suffered long ago.

Walt Whitman plays the parts of everyone, representing the choice (w) *all of the above,* in a familiar poem which begins:

> I am of old and young, of the foolish as much as the wise,
> Regardless of others, ever regardful of others,
> Maternal as well as paternal, a child as well as a man,
> Stuff'd with the stuff that is coarse and stuff'd with the stuff
> that is fine. . . .

My own answer to our test is (x) *all of the above, and more besides,* because I have seen and read and written so much more (and thought and felt so much more) than I could possibly include in this book!

However, a case can be made for (y) *none of the above.* The book does include some things that do not fit into any of the previous categories. For example, there are poems by James Emanuel and James Dickey that illustrate needs for privacy and for what is now called "male bonding," apart from spouses and children. There are also several strong statements about male sexuality, including the majestic poem "Lament" by Dylan Thomas and an excerpt from Tennessee Williams's play *Cat on a Hot Tin Roof.* Some readers might wonder if these selections really describe fatherhood. Others might consider them reminders of the conventional wisdom that men may not always be fathers, but fathers are always men.

And so we come to the final answer on my list, (z) *some of the above, but which?* Whether or not this was your first choice, I hope you will read the book, enjoy it, think about it, and then perhaps decide.

CHARLES SULLIVAN
WASHINGTON, D.C.

And God Said, Let Us Make Man in Our Image
The Book of Genesis 1: 26–28

And God said, Let us make man in our image, after our likeness: and let them have dominion over the fish of the sea, and over the fowl of the air, and over the cattle, and over all the earth, and over every creeping thing that creepeth upon the earth.

So God created man in his *own* image, in the image of God created he him; male and female created he them.

And God blessed them, and God said unto them, Be fruitful, and multiply, and replenish the earth, and subdue it: and have dominion over the fish of the sea, and over the fowl of the air, and over every living thing that moveth upon the earth.

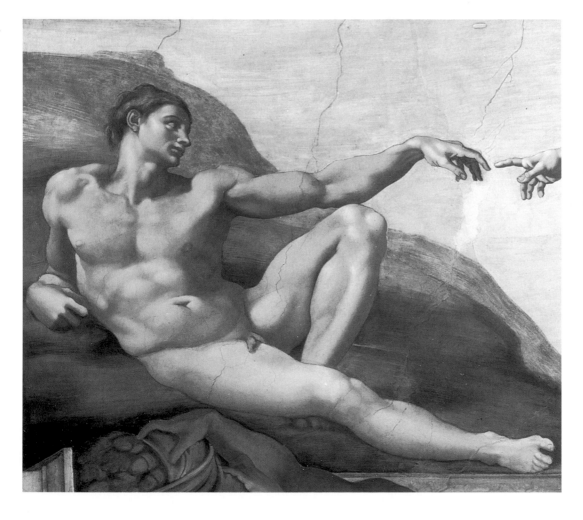

The Creation of Adam (detail) by Michelangelo. 1508–12. Ceiling fresco, after restoration. Sistine Chapel, Vatican, Rome

We Believed He Would Come Back and Make Me a Daughter Again
from *The Lost Father*

Mona Simpson

We believed in an altogether different life than the one we had, my mother and I. We wanted brightness. We believed in heaven. We thought a man would show us there. First it was my father. We believed he would come back and make me a daughter again, make my mother a wife. My grandmother did not like him, but I prayed for her anyway. If he came, we didn't want her to be left behind.

My mother never lost her faith in men, but after years, it became more general. She believed a man would come and be my father, some man. It didn't have to be our original one, the one we'd prayed to first as one and only. Any man with certain assets would do.

Rest in His Hands by Käthe Kollwitz. c. 1936. Bronze relief, 13¼ × 12⅛ × 1¼". The National Museum of Women in the Arts, Washington, D.C. Gift of Wallace and Wilhelmina Holladay

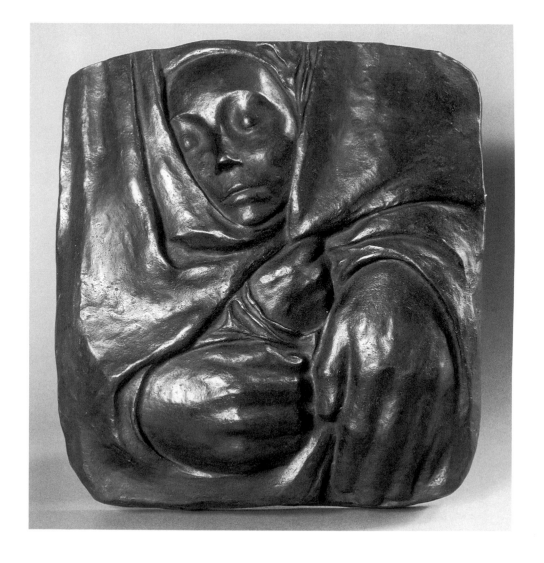

Nobody Knows about Children

from an interview, September 1980

John Lennon

I would say, "I'm baking bread," and they'd [friends] say, "What are you *really* doing?" I'd say, "I'm looking after the baby." They'd say, "But what *else* do you do?" I'd say, "Are you kidding?!" There were no secret projects in the basement, because bread and babies, as every housewife knows, is a full-time job....

I don't try and be the God Almighty kind of father figure that is always smiling and such a wonderful father. I'm not into putting out an image of this person who knows all about children. Nobody knows about children. That's the thing. You look in books. There are no real experts. But now I feel as though at least I've put my body where my mouth was and tried to really live up to my own preaching, as it were.

John Lennon, Age 6.
Photographer unknown.
© Yoko Ono Lennon

The World He Made Was a Boy's Heaven
from *"Time and My Father's Cousin"*

John Holmes

The world he and time made was a boy's heaven: pistols, nails,
 tools, on a table
Where you could get at them: the *Santa Maria* to finish rigging,
 tomorrow, maybe;
Foreign stamps, cat-gut for clock-weights, important lengths of
 copper chain.
And he was the boy in it. Till the day he died, all this wonder-
 ful junk was his,
And it's all gone now where things go when they're really junk,
 not wonderful,
I don't know where, but I wish I had some of it. They gave me
 his calipers, yes,
But what became of the Toby jugs, the pewter plates? Who got
 the three hundred clay pipes?

Time and my father's cousin smile and smoke, no hurry now to
 get things picked up,
Nobody else cares now about the missing part of a clock, or
 Volumes I and II,
Not even in heaven, or even less so there. Heaven is a back
 room, second floor,
Unsorted *National Geographics* behind the door, so you bump
 the pile coming in.
The pencils lean points up forever against the nose of the bust
 of Mozart,
The unglassed greenish print of *The Flying Dutchman* hangs for
 eternity crooked.

My father lights his pipe. The bright golden match-flame pours
 down, rises,
And the blue smoke blows. I am the one in brown corduroy
 knickers, a young ghost
To them, out of the future, but happy, who pokes at the chessmen,
 tools, clock-parts.
They cross their legs and chuckle, talk leisurely over my head,
 not much over.
I ache wishing they would give me the *Mayflower* model, or better,
 the *Santa Maria*.
What if it isn't rigged yet? So beautiful, so perfect, so small,
 and I want it....

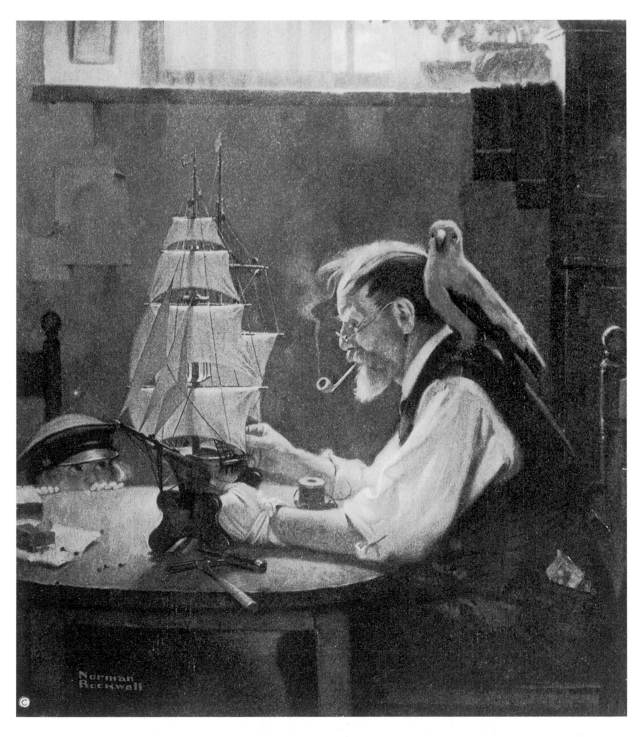

Old Sea Captain by Norman Rockwell. c. 1922. Cover of *Literary Digest Magazine,*
December 2, 1922

Each Morning
section 4 from *"Hymn for Lanie Poo"*

LeRoi Jones

Each morning
I go down
to Gansevoort St.
and stand on the docks.
I stare out
at the horizon
until it gets up
and comes to embrace
me. I
make believe
it is my father.
This is known
as genealogy.

Being a Dad.
Photograph by James A.
Parcell. 1993

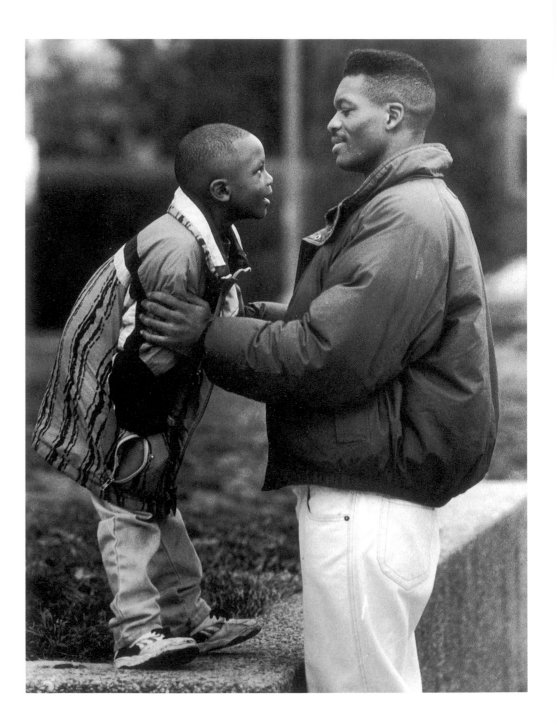

People Are What They Are Made
from *Dear Boy: Lord Chesterfield's Letters to His Son*

Observe the difference there is between minds cultivated and minds uncultivated, and you will, I am sure, think you cannot take too much pains, nor employ too much of your time in the culture of your own. A drayman is probably born with as good organs as Milton, Locke, or Newton; but, by culture, they are much more above him than he is above his horse. Sometimes, indeed, extraordinary geniuses have broken out by the force of nature, without the assistance of education; but those instances are too rare for anybody to trust to; and even they would make a much greater figure, if they had the advantage of education into the bargain. If Shakespeare's genius had been cultivated, those beauties, which we so justly admire in him, would have been undisguised by those extravagances and that nonsense with which they are frequently accompanied.

People are, in general, what they are made, by education and company, from fifteen to five-and-twenty; consider well, therefore, the importance of your next eight or nine years—your whole depends upon them.

The Key to Heredity
from *The Double Helix*

James D. Watson

Before my arrival in Cambridge, Francis [Crick] only occasionally thought about deoxyribonucleic acid (DNA) and its role in heredity. This was not because he thought it uninteresting. Quite the contrary. A major factor in his leaving physics and developing an interest in biology had been the reading in 1946 of *What is Life?* by the noted theoretical physicist Erwin Schrödinger. This book very elegantly propounded the belief that genes were the key components of living cells and that, to understand what life is, we must know how genes act. When Schrödinger wrote his book (1944), there was general acceptance that genes were special types of protein molecules. But almost at this same time the bacteriologist O. T. Avery was carrying out experiments at the Rockefeller Institute in New York which showed that hereditary traits could be transmitted from one bacterial cell to another by purified DNA molecules.

Given the fact that DNA was known to occur in the chromosomes of all cells, Avery's experiments strongly suggested that future experiments would show that all genes were composed of DNA. If true, this meant to Francis that proteins would not be the Rosetta Stone for unravelling the true secret of life. Instead, DNA would have to provide the key to enable us to find out how the genes determined, among other characteristics, the colour of our hair, our eyes, most likely our comparative intelligence, and maybe even our potential to amuse others.

Of course there were scientists who thought the evidence favouring DNA was inconclusive and preferred to believe that genes were protein molecules. Francis, however, did not worry about these sceptics. Many were cantankerous fools who unfailingly backed the wrong horses. One could not be a successful scientist without realizing that, in contrast to the popular conception supported by newspapers and mothers of scientists, a goodly number of scientists are not only narrow-minded and dull, but also just stupid.

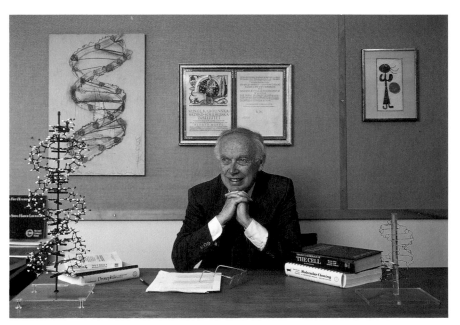

Portrait of James Watson shown with early and later models of the DNA molecule, c. 1990. Photograph by Yousuf Karsh

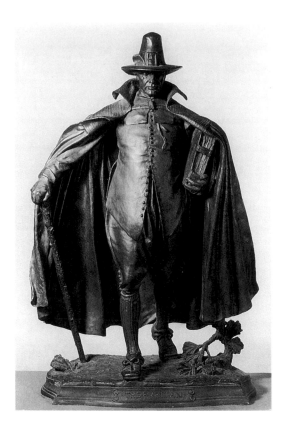

The Puritan by Augustus Saint-Gaudens. 1887.
Bronze, height 30½". The New York Historical Society, New York

Down to the Puritan Marrow of My Bones
from *"Wild Peaches"*

Elinor Wylie

Down to the Puritan marrow of my bones
There's something in this richness that I hate.

I love the look, austere, immaculate,
Of landscapes drawn in pearly monotones.
There's something in my very blood that owns
Bare hills, cold silver on a sky of slate,
A thread of water, churned to milky spate
Streaming through slanted pastures fenced with stones.

I love those skies, thin blue or snowy gray,
Those fields sparse-planted, rendering meagre sheaves;
That spring, briefer than apple-blossom's breath,
Summer, so much too beautiful to stay,
Swift autumn, like a bonfire of leaves,
And sleepy winter, like the sleep of death.

The Father of His Country
from *"Ode Recited at the Harvard Commemoration"*

James Russell Lowell

I praise him not; it were too late;
And some innative weakness there must be
In him who condescends to victory
Such as the Present gives, and cannot wait,
 Safe in himself as in a fate.
 So always firmly he:
 He knew to bide his time,
 And can his fame abide,
Still patient in his simple faith sublime,
 Till the wise years decide.
 Great captains, with their guns and drums,
 Disturb our judgment for the hour,
 But at last silence comes;
These all are gone, and, standing like a tower,
Our children shall behold his fame,
The kindly-earnest, brave, foreseeing man,
Sagacious, patient, dreading praise, not blame,
New birth of our new soil, the first American.

Daughters of the Revolution by Grant Wood. 1932. Oil on masonite, 20 × 40″. Cincinnati Art Museum, Ohio. The Edwin and Virginia Irwin Memorial

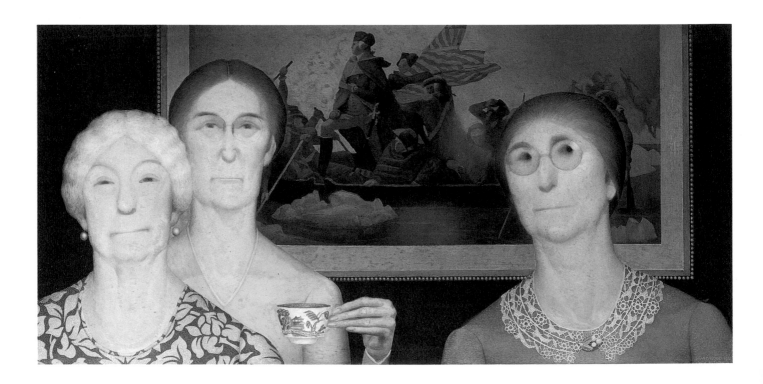

We And That Protecting Father Are One
from *The Hero with a Thousand Faces*

Joseph Campbell

Peace is at the heart of all because Avalokiteshvara-Kwannon, the mighty Bodhisattva, Boundless Love, includes, regards, and dwells within (without exception) every sentient being. The perfection of the delicate wings of an insect, broken in the passage of time, he regards—and he himself is both their perfection and their disintegration. The perennial agony of man, self-torturing, deluded, tangled in the net of his own tenuous delirium, frustrated, yet having within himself, undiscovered, absolutely unutilized, the secret of release: this too he regards—and is. Serene above man, the angels; below man, the demons and unhappy dead: these all are drawn to the Bodhisattva by the rays of his jewel hands, and they are he, as he is they. The bounded, shackled centers of consciousness, myriadfold, on every plane of existence (not only in this present universe, limited by the Milky Way, but beyond, into the reaches of space), galaxy beyond galaxy, world beyond world of universes, coming into being out of the timeless pool of the void, bursting into life, and like a bubble therewith vanishing: time and time again: lives by the multitude: all suffering: each bounded in the tenuous, tight circle of itself—lashing, killing, hating, and desiring peace beyond victory: these all are the children, the mad figures of the transitory yet inexhaustible, long world dream of the All-Regarding, whose essence is the essence of Emptiness: "The Lord Looking Down in Pity."

But the name means also: "The Lord Who is Seen Within." We are all reflexes of the image of the Bodhisattva. The sufferer within us is that divine being. We and that protecting father are one. This is the redeeming insight. That protecting father is every man we meet.

Tibetan painting (Kakemono Form) illustrating Jataka Tales (detail). 18th century. The Saint Louis Art Museum. Purchase, W. K. Bixby Oriental Art Fund

The Patter of Little Feet
from *"Songs My Father Sang Me"*

Elizabeth Bowen

My father was one of the young men who were not killed in the last war. He was a man in the last war until that stopped; then I don't quite know what he was, and I don't think he ever quite knew either. He got his commission and first went out to France about 1915, I think he said. When he got leaves he got back to London and had good times, by which I mean something larky but quite romantic, in the course of one of which, I don't know which one, he fell in love with my mother and they used to go dancing, and got engaged in that leave and got married the next. My mother was a flapper, if you knew about flappers? They were the pin-ups *de ses jours*, and at the same time inspired idealistic feeling. My mother was dark and fluffy and slim as a wraith; a great *glacé* ribbon bow tied her hair back and stood out like a calyx behind her face, and her hair itself hung down in a plume so long that it tickled my father's hand while he held her while they were dancing and while she sometimes swam up at him with her velvet eyes. Each time he had to go back to the front again she was miserable, and had to put her hair up, because her relations said it was high time. But sometimes when he got back again on leave she returned to being a flapper again, to please him. Between his leaves she had to go back to live with her mother and sisters in West Kensington; and her sisters had a whole pack of business friends who had somehow never had to go near the front, and all these combined in an effort to cheer her up, but, as she always wrote to my father, nothing did any good. I suppose everyone felt it was for the best when they knew there was going to be the patter of little feet. I wasn't actually *born* till the summer of 1918....

Baby by Gustav Klimt. 1917–18. Oil on canvas, 43⅝ × 43½″. National Gallery of Art, Washington, D.C. Gift of Otto and Franziska Kallir with the help of the Carol and Edwin Gaines Fullinwider Fund

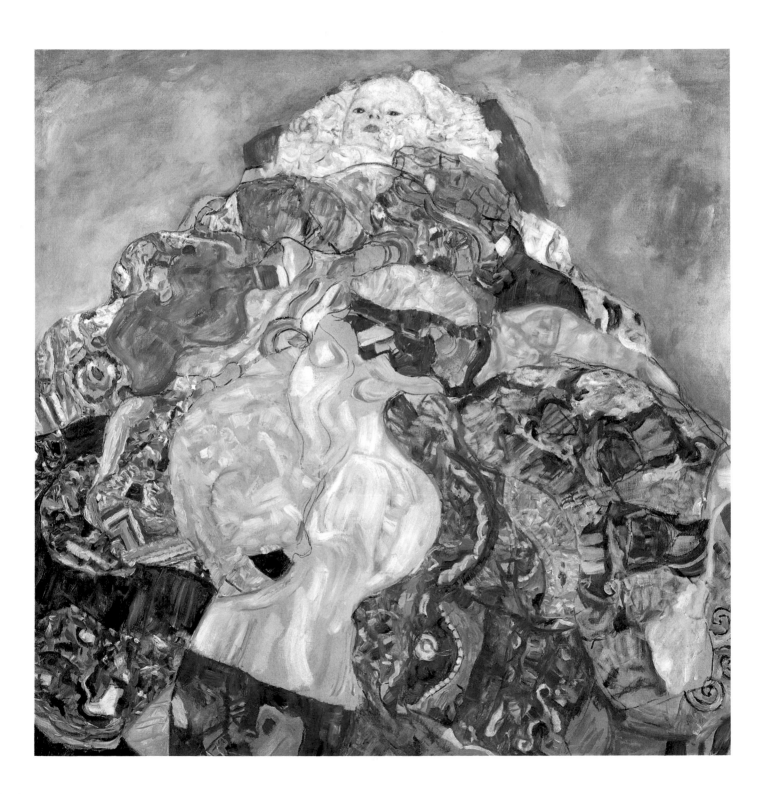

I Am Tired, But This Will Pass
from *The Journals of John Cheever*

I am tired, but this will pass. I love my wife's body and my children's innocence.
Nothing more.

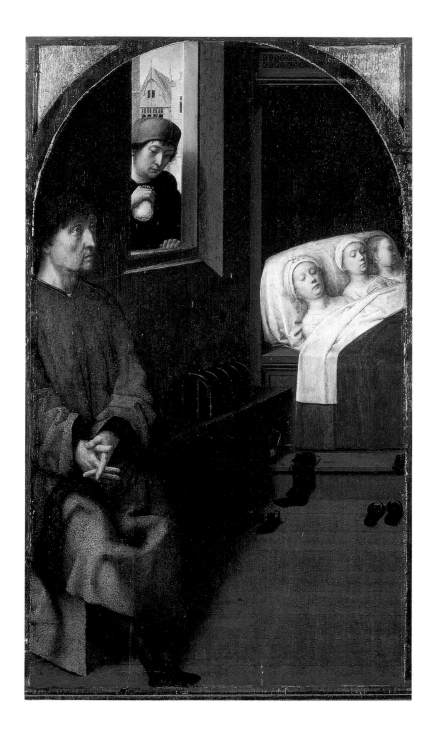

*Saint Nicholas Slipping a Purse
Through the Window of an
Impoverished Nobleman* by Gérard
David. c. 1500. Oil on panel,
22 × 13¼″. National Galleries of
Scotland, Edinburgh

Advice to a Father

from a letter by Saint Ignatius of Loyola to Martin Garcia de Oñaz, his brother

Paris, June 1532

IHS

May the grace and love of Christ our Lord be ever with us.

Your letter brought me great satisfaction in the service and love of the Divine Majesty because of the news it gives me of your daughter and the plans you have for your son. May the Divine Majesty be pleased with all our intentions and order them to His praise and

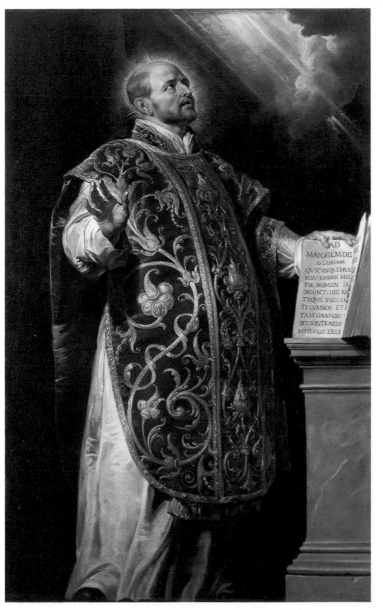

service, and allow you to persevere in these good purposes and prosper them when you so direct them. If you have no better plan, I do not think that you will make any mistake in having him take theology rather than canon law, for theology is a field in which he will find it easier to amass the riches that do not fail, and which will give you added comfort in your old age. Nor do I think that you will find anywhere in Europe greater advantages than here at Paris. I should judge that if you allow him fifty ducats a year, he will be able to meet all expenses, tutor's fees and other charges. He will be in a foreign land, with different ways and a colder climate, and I am sure that you would not want him to suffer any need that might interfere with his studies; so it seems to me. Even from the point of view of expense, I am sure that he will find it cheaper, as he will be able to accomplish here in four years what it would take him six to do elsewhere, even more, I think I can say without straying from the truth. If you agree with me and send him here, it would be good to see that he arrives a week before the feast of St. Remy, the first of October next, as the courses in philosophy begin then. If he is well grounded in grammar he could begin his philosophy by that date. Should he come a little late, he will have to wait a whole year until the feast of St. Remy, when the course will begin over again.

Saint Ignatius of Loyola by Peter Paul Rubens. c. 1620–22. Oil on canvas, 88 × 54½". Norton Simon Museum, Pasadena, California

The Great White Father

from a letter by Noche (Apache scout for U.S. Army)

[To General George Crook, January 2, 1890,
Mount Vernon Barracks, Alabama]

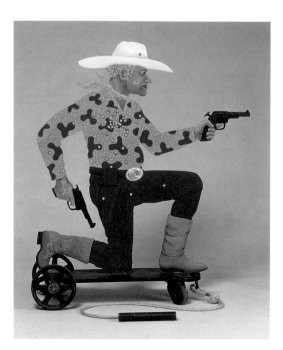

Apache Pull-Toy by Bob Haozous. 1988. Cut and painted steel, 54 × 48 × 16". Hood Museum of Art, Dartmouth College, Hanover, New Hampshire. Purchased through the Joseph B. Obering '56 Fund

I remember all General Crook told me and also all that General Miles told me. He told me how to behave myself. He told me to go back to Camp Apache. I had a farm there.... I went back there and made a big farm and worked it.... I got a contract for wood ... and got a good deal of money from it.... General Miles told me, "... now I'll have to send you away. People don't seem to like you." I told him there was lots of wood here, and I wanted to stay. He said, "The Indians at San Carlos and Camp Apache are talking about you all the time, and I had better send you away from here. We will take the train and in one and a quarter days we will go to the place we were talking about and look at it." We didn't see that land. We were four days on the train and stopped only when we reached Washington. I saw the President and shook hands with him. He told us, "Do not be afraid to come amongst us; I am the great father of you all. Go back to your farms at Camp Apache and settle down quietly. There nobody will harm you, nobody will say anything to you. Go back there and do just as the commanding officer tells you. Do as he tells you and he will write good letters to me about you." He told us when we got in the [railroad] cars it would be about a week before we got home, but when we had been on two days we were stopped [at Fort Leavenworth] and they told us we would not go back to Camp Apache. We were there two months and they told us we would not go back to our homes any more, but would go some place on the coast.

On the evening of the third day after we got to St. Augustine our people came there from Camp Apache. We were told then we would be in confinement.... We were told we would have our stock; we were told this after we had reached the east. What horses we had were finally sold and we got what few dollars were received for them. I had four horses and three mules and received $127 for them. I received pay for my horses but not for the wood I had piled up there. I had about 90 cords of wood for which I never received anything.

I thought we were coming to a place that was healthy, but you can see for yourself that we are not so many as when you saw us last. A great many have died. We lost more than a hundred. More than fifty have died since leaving St. Augustine. About thirty children have died at Carlisle. Between fifty and a hundred have died here. Chatto had a son and nephew to die at Carlisle.... They told me about that big reservation that General Miles told him about, where all the Indians should be together. He said, "When you get there you will have good farms, horses, cattle, and they will belong to you. Nobody will have anything to do with them but yourself. I am telling you the truth; I am telling you no lie." When he told me that, I shook hands with him two or three times and said, "Thank you."

Not Saying Much

Linda Gregg

My father is dead and there is nothing left
now except ashes and a few photographs.
The men are together in the old pictures.
Two generations of them working and boxing
and playing fiddles. They were interested
mostly in how men were men. Muscle and size.
Played their music for women and the women
did not. The music of women was long ago.
Being together made the men believe somehow.
Something the United States of America could
not give them. Not even the Mississippi.
Not running away or the Civil War or farming
the plains. Not exploring or the dream of gold.
The music and standing that way together
seems to have worked. They married women
the way they made a living. And the women
married them back, without saying much,
not loving much, not singing ever.
Those I knew in California lived and died
in beauty and not enough money. But the beauty
was like a face with the teeth touching
under closed lips and the eyes still. The men
did not talk to them much, and neither time
nor that fine place gave them a sweetness.

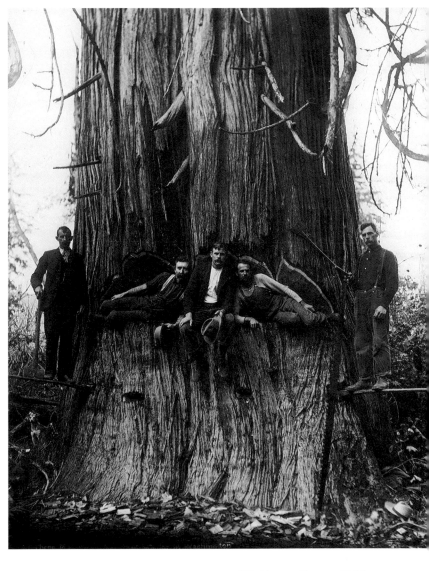

Washington State c. 1905.
Photograph by
Darius Kinsey. Darius
Kinsey Collection,
Whatcom Museum of
History and Art,
Bellingham,
Washington

Driving Sawlogs on the River

from a folk song

O Johnnie, you were your father's hope,
Your mother's only joy.
Why is it that you ramble so,
My own, my darling boy?

What could induce you, Johnnie,
From your own dear home to stray,
Driving sawlogs on the river?
and you'll never get your pay.

I Am of Old and Young
from *"Song of Myself"*

Walt Whitman

I am of old and young, of the foolish as much as the wise,
Regardless of others, ever regardful of others,
Maternal as well as paternal, a child as well as a man,
Stuff'd with the stuff that is coarse and stuff'd with the stuff
 that is fine,
One of the Nation of many nations, the smallest the same
 and the largest the same,
A Southerner soon as a Northerner, a planter nonchalant
 and hospitable down by the Oconee I live,
A Yankee bound my own way ready for trade, my joints the
 limberest joints on earth and the sternest joints on earth,
A Kentuckian walking the vale of the Elkhorn in my deerskin
 leggings, a Louisianian or Georgian,
A boatman over lakes or bays or along coasts, a Hoosier, Badger,
 Buckeye;
At home on Kanadian snow-shoes or up in the bush, or with
 fishermen off Newfoundland,
At home in the fleet of ice-boats, sailing with the rest and tacking,
At home on the hills of Vermont or in the woods of Maine, or
 the Texan ranch,
Comrade of Californians, comrade of free North-Westerners,
 (loving their big proportions,)
Comrade of raftsmen and coalmen, comrade of all who shake
 hands and welcome to drink and meat,
A learner with the simplest, a teacher of the thoughtfullest,
A novice beginning yet experient of myriads of seasons,
Of every hue and caste am I, of every rank and religion,
A farmer, mechanic, artist, gentleman, sailor, quaker,
Prisoner, fancy-man, rowdy, lawyer, physician, priest.

I resist any thing better than my own diversity,
Breathe the air but leave plenty after me,
And am not stuck up, and am in my place.

Lumberjack Mike Ladouceur and His
Daughter Jessie, Washington State.
Photograph by Sandy Felsenthal. 1988

28

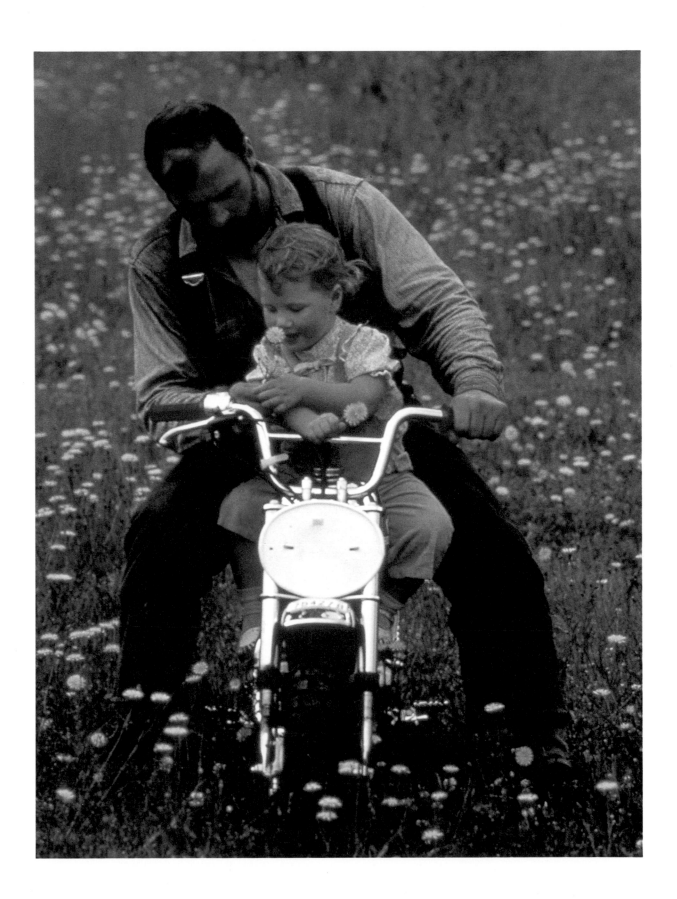

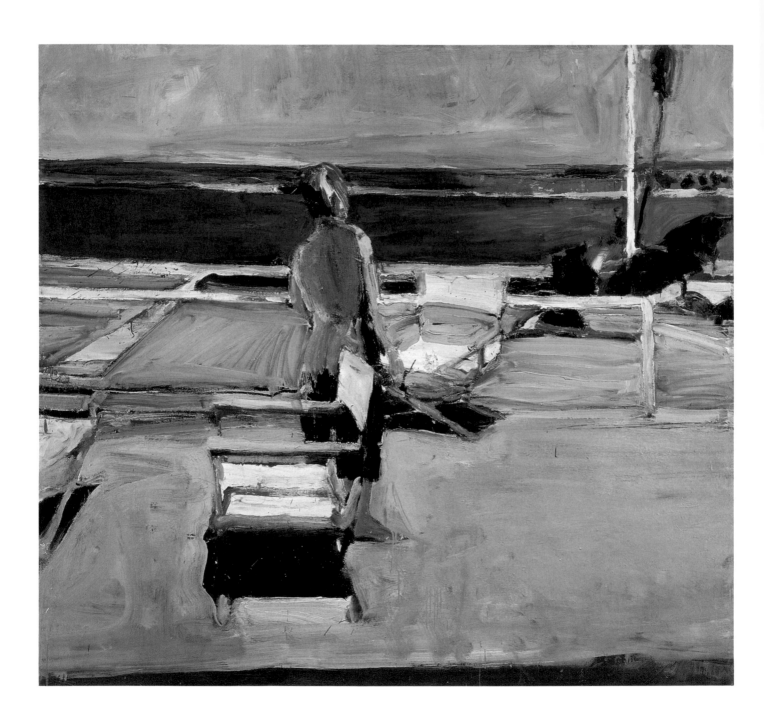

What If the Children Never Come Back?
from *"In a Father's Place"*

Christopher Tilghman

He lowered his legs over the dock planking and sat looking out into the Bay. From this spot, he had watched the loblolly pines on Carpenter's Island fall one by one across the low bank into the irresistible tides. When the last of the pines had gone, the island itself was next, and it sank finally out of sight during the hurricanes of the fifties. Across the creek Mr. McHugh's house stood empty, blindfolded by shutters. What was to become of the place now that the old man's will had scattered it among nieces and nephews? What was to happen to his own family ground if Rachel went to Seattle for good and Nick … and Nick left this afternoon never to come back?

Dan tried to think again of what he would say to Nick, what his expression should be as they closed upon the mooring, what his first words should cover. But the wind that had already brought change brushed him clean of all that and left him naked, a man. He could not help the rising tide of joy that was coming to him. He was astonished by what had happened to him. By his life. By the work he had done, the wills, the clients, all of them so distant that he couldn't remember ever knowing them at all. By the wife he had loved, and lost on the main street of Easton, and by the women who had since then come in and out of his life, leaving marks and changes he'd never even bothered to notice. By the children he had fathered and raised, those children looking out from photographs over mounds of Christmas wrappings and up from the water's edge, smiles undarkened even by their mother's death. By his mistakes and triumphs, from the slap of a doctor's hand to the last bored spadeful of earth. It was all his, it all accumulated back toward him, toward his body, part of a journey back through the flesh to the seed where it started, and would end.

Figure on a Porch by Richard Diebenkorn. 1959. Oil on canvas, 57 × 62". The Oakland Art Museum, California. Anonymous gift through American Federation of Arts

N. Y. TO GRENITCH 500.0
from *"The Young Immigrunts"*

Ring Lardner

The lease said about my and my fathers trip from the Bureau of Manhattan to our new home the soonest mended. In some way ether I or he got balled up on the grand concorpse and next thing you know we was thretning to swoop down on Pittsfield.

Are you lost daddy I arsked tenderly.

Shut up he explained.

At lenth we doubled on our tracks and done much better as we finley hit New Rochelle and puled up along side a policeman with falling archs.

What road do I take for Grenitch Conn quired my father with poping eyes.

Take the Boston post replid the policeman.

I have all ready subscribed to one out of town paper said my father and steped on the gas so we will leave the flat foot gaping after us like a prune fed calf and end this chapter.

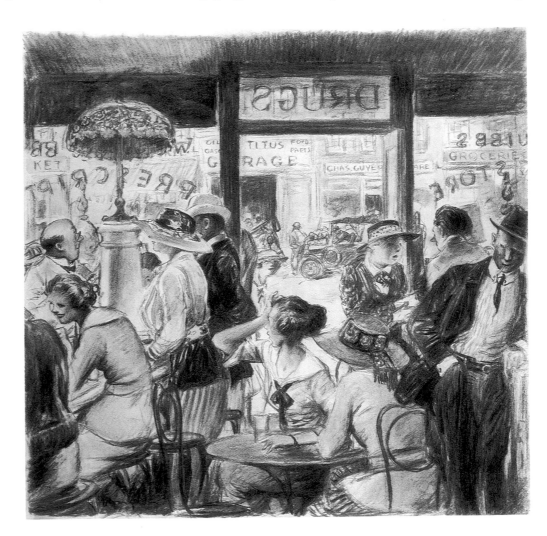

Drug Store, Main Street by George Wright. c. 1920. Charcoal and watercolor, 15½ × 16″. New Britain Museum of American Art, Connecticut

My Father Wouldn't Learn to Drive a Car
from *"Gentleman from Indiana"*

James Thurber

My father wouldn't learn to drive a car, and he was always uneasy in one. Nobody could outwalk him. He would even go on foot to Ohio Stadium for football games, a distance of several miles from our house. When he was visiting me in New York one time, he asked me how long it would take to walk from New York to Litchfield, Connecticut. I told him I didn't know about him—he was in his sixties—but it would take me a month and a half. He looked a little wistful, but he gave up the preposterous idea and settled for a jaunt with me up Fifth Avenue from Washington Square to 110th Street, pointing out on the way a hundred things I would not have noticed myself, including a small bronze tablet bearing the Gettysburg Address, which you will still see, if you look sharp, on the facade of a building in the Twenties. If there was a dog on a roof, a potted plant on a window sill high above the street, a misspelled word in a sign, a dime on the sidewalk, his practiced eye took it in. He gave the same scrupulous attention to anyone who had something to say or something to argue. He listened intently to conversation for the unusual statement or the remarkable fact. He was never guilty of that glibbest of human faults, the habit of quick and automatic refutation. He could remember a speech or lecture almost as accurately as if he had taken it down in shorthand. If he had a hard day ahead, or an imposing task to face, he would get up early and bathe, singing, off key, "My Bonnie Lies Over the Ocean," or an old song, in the Riley dialect, called "Just One Girl." Frustration, indignation, or deep annoyance would send him to his bureau, where I used to watch him vigorously brushing his hair for at least five minutes with a pair of military brushes. When the world pressed in too strongly upon him, he would take a train to Indianapolis and walk along Lockerbie Street. My mother still has a letter he wrote her from there when he was twenty-one, in which he said, "I feel as sure that you and I will be married as I do that we will some time end our existence here." In this letter, in which he told her that he would be in Columbus the following Sunday, he wrote, "I would be delighted beyond expression to take you to church." The church he took her to was the Methodist Church near my grandfather's house, and soon afterward he and Mary Agnes Fisher were married there. He ended his existence in Columbus fifty years later, at the age of seventy-two. Among the hundreds of letters my mother received was one from John McNulty. "Charley Thurber," he wrote at the end, "was a good-minded man."

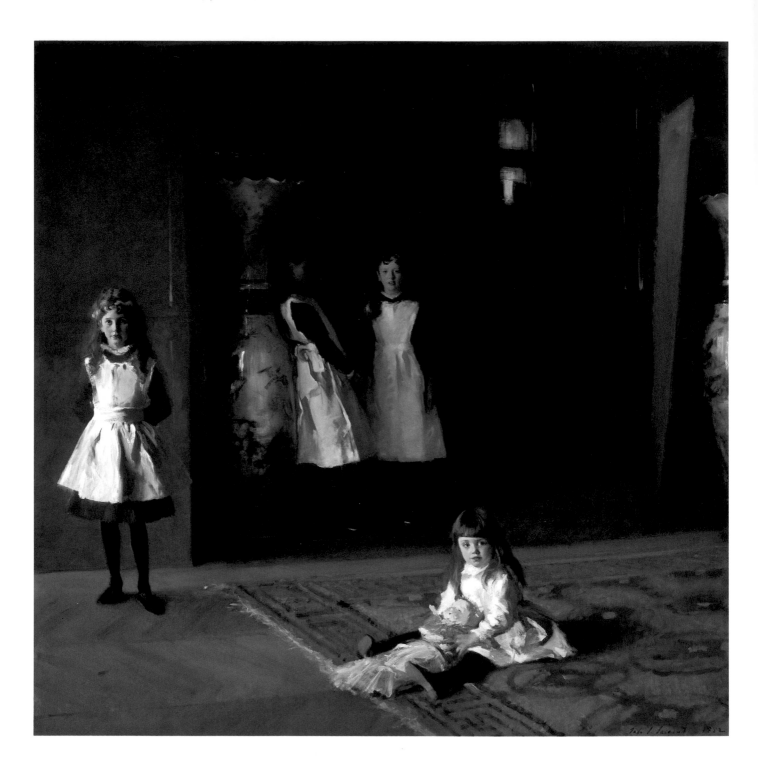

The Children's Hour

Henry Wadsworth Longfellow

Between the dark and the daylight,
 When the night is beginning to lower,
Comes a pause in the day's occupations
 That is known as the Children's Hour.

I hear in the chamber above me
 The patter of little feet,
The sound of a door that is opened,
 And voices soft and sweet.

From my study I see in the lamplight,
 Descending the broad hall stair,
Grave Alice, and laughing Allegra,
 And Edith with golden hair.

They almost devour me with kisses,
 Their arms about me entwine,
Till I think of the Bishop of Bingen
 In his Mouse-Tower on the Rhine!

Do you think, O blue-eyed banditti,
 Because you have scaled the wall,
Such an old mustache as I am
 Is not a match for you all?

A whisper, and then a silence:
 Yet I know by their merry eyes
They are plotting and planning together
 To take me by surprise.

A sudden rush from the stairway,
 A sudden raid from the hall!
By three doors left unguarded
 They enter my castle wall!

They climb up into my turret
 O'er the arms and back of my chair;
If I try to escape, they surround me;
 They seem to be everywhere.

I have you fast in my fortress,
 And will not let you depart,
But put you down into the dungeon
 In the round-tower of my heart.

And there I will keep you forever,
 Yes, forever and a day,
Till the wall shall crumble to ruin,
 And molder in dust away!

The Daughters of Edward Darley Boit by John Singer Sargent. 1882. Oil on canvas, 87 × 87″. Museum of Fine Arts, Boston, Massachusetts. Gift of Mary Louisa Boit, Florence D. Boit, Jane H. Boit, and Julia O. Boit, in memory of their father

We Are a Very Happy Family!
from
Papa, an Intimate Biography of Mark Twain
Olivia Susan Clemens

We are a very happy family! we consist of papa, mamma, Jean Clara and me. It is papa I am writing about, and I shall have no trouble in not knowing what to say about him, as he is a very striking character. Papa's appearance has been discribed many times, but very incorectly; he has beautiful curly grey hair, not any too thick, or any too long, just right; A roman nose, which greatly improves the beauty of his features, kind blue eyes, and a small mustache, he has a wonderfully shaped head, and profile, he has a very good figure in short he is an extrodinarily fine looking man. All his features are perfect exept that he hasn't extrodinary teeth. His complexion is very fair, and he doesn't ware a beard.

He is a very good man, and a very funny one; he *has* got a temper but we all of us have in this family. He is the loveliest man I ever saw, or ever hope to see, and oh *so* absent minded! He does tell perfectly delightful stories, Clara and I used to sit on each arm of his chair, and listen while he told us stories about the pictures on the wall.

In This Family She Held the Place of Intellectual Chief
from *Mark Twain's Notebook*

In this family she held the place of intellectual chief, as by natural right; none of us thought of disputing it with her. In depth of mind, in swiftness of comprehension, clearness of intellectual vision, in ability to reveal the meaning of an obscure page with a simple flash from her mind upon it and in the ability to transmute her thoughts into the crispest of English by instantaneous process, we knew her for our superior. And we did not resent it but were only proud of it.

Livy: "Others that are bereaved say 'Be comforted—time will heal the wound.' What do *they* know? They have not lost a Susy Clemens."

How is it that I, who cannot draw or paint, can sometimes shut my eyes and see faces (dark colored always, color of putty) most delicate and perfect miniatures and can note and admire the details. How is it? They are not familiar faces, they are new—how can I invent them? And what is it that makes perfect images in my dreams? I cannot *form* a face of any kind by deliberate effort of imagination.

Samuel L. Clemens (Mark Twain) and His Daughter Susy as "Hero and Leander," Onteroa, N.Y., c. 1890. Photograph. Collection Mark Twain House, Hartford, Connecticut. Having written her father's biography when she was thirteen, Susy Clemens died at age twenty-two.

To a Child Running with Outstretched Arms in Canyon de Chelly

N. Scott Momaday

You are small and intense
In your excitement, whole,
Embodied in delight.
The backdrop is immense;

The sand drifts break and roll
Through cleavages of light
And shadow. You embrace
The spirit of this place.

The Ancient Ruins in the Canyon de Chelly, Arizona. Photograph by Timothy O'Sullivan. 1873. National Archives, Washington, D.C.

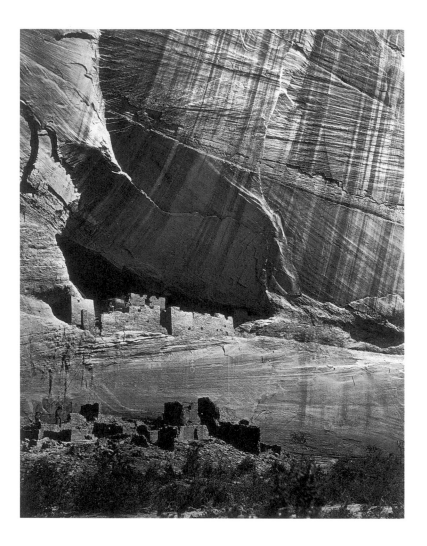

Winter at Saroke. Photograph by Edward S. Curtis. 1907. Rare Books and Manuscripts Division, The New York Public Library. Astor, Lenox and Tilden Foundations

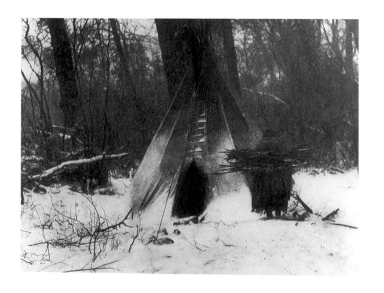

Grandfather

Lance Henson

the visions you never saw
still deliver me from the void

you stay now
beyond
where the snow is
no longer pain

wait for me wait for me

i will follow

A Record Stride

Robert Frost

In a Vermont bedroom closet
With a door of two broad boards
And for back wall a crumbling old chimney
(And that's what their toes are towards),

I have a pair of shoes standing,
Old rivals of sagging leather,
Who once kept surpassing each other,
But now live even together.

They listen for me in the bedroom
To ask me a thing or two
About who is too old to go walking,
With too much stress on the who.

I wet one last year at Montauk
For a hat I had to save.
The other I wet at the Cliff House
In an extra-vagant wave.

Two entirely different grandchildren
Got me into my double adventure.
But when they grow up and can read this
I hope they won't take it for censure.

I touch my tongue to the shoes now,
And unless my sense is at fault,
On one I can taste Atlantic,
On the other Pacific, salt.

One foot in each great ocean
Is a record stride or stretch.
The authentic shoes it was made in
I should sell for what they would fetch.

But instead I proudly devote them
To my museum and muse;
So the thick-skins needn't act thin-skinned
About being past-active shoes.

And I ask all to try to forgive me
For being as overelated
As if I had measured the country
And got the United States stated.

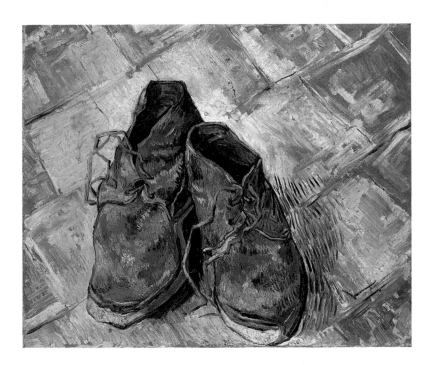

Shoes by Vincent van Gogh. 1888. Oil on canvas, 17³⁄₈ × 20⁷⁄₈".
The Metropolitan Museum of Art, New York. Purchase,
The Annenberg Foundation Gift

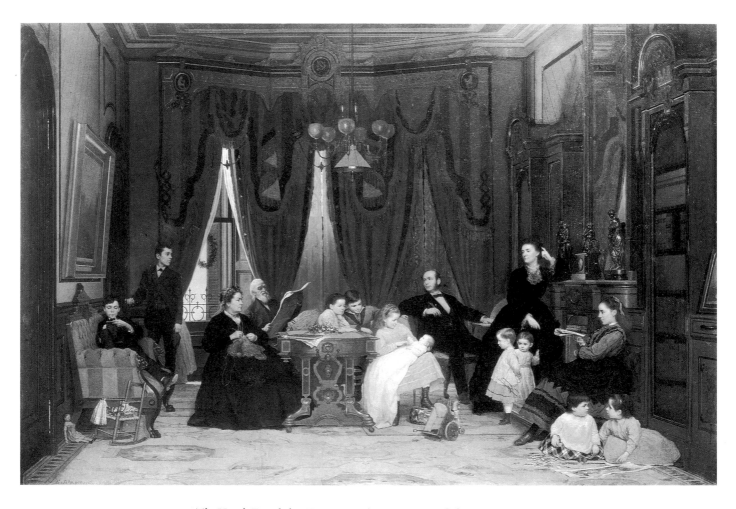

The Hatch Family by Eastman Johnson. 1871. Oil on canvas,
48 × 73⅜″. The Metropolitan Museum of Art, New York.
Gift of Frederic H. Hatch, 1926

Family Portrait

Carlos Drummond de Andrade

translated from Portuguese by Elizabeth Bishop

Yes, this family portrait
is a little dusty.
The father's face doesn't show
how much money he earned.

The uncles' hands don't reveal
the voyages both of them made.
The grandmother's smoothed and yellowed;
she's forgotten the monarchy.

The children, how they've changed.
Peter's face is tranquil,
that wore the best dreams.
And John's no longer a liar.

The garden's become fantastic.
The flowers are gray badges.
And the sand, beneath dead feet,
is an ocean of fog.

In the semicircle of armchairs
a certain movement is noticed.
The children are changing places,
but noiselessly! it's a picture.

Twenty years is a long time.
It can form any image.
If one face starts to wither,
another presents itself, smiling.

All these seated strangers,
my relations? I don't believe it.
They're guests amusing themselves
in a rarely-opened parlor.

Family features remain
lost in the play of bodies.

But there's enough to suggest
that a body is full of surprises.

The frame of this family portrait
holds its personages in vain.
They're there voluntarily,
they'd know how—if need be—to
 fly.

They could refine themselves
in the room's chiaroscuro,
live inside the furniture
or the pockets of old waistcoats.

The house has many drawers,
papers, long staircases.
When matter becomes annoyed,
who knows the malice of things?

The portrait does not reply,
it stares; in my dusty eyes
it contemplates itself.
The living and dead relations

multiply in the glass.
I don't distinguish those
that went away from those
that stay. I only perceive
the strange idea of family

travelling through the flesh.

Mother Was the One His Eye Followed
from *Life With Father*

Clarence Day

When he sat next to some pretty woman at table, his eye would light up and he would feel interested and gallant. He had charm. Women liked him. It never did them any good to like him if the wine wasn't good, or if the principal dishes weren't cooked well. That made him morose. But when the host knew his business, Father was gay and expansive, without ever a thought of the raps Mother would give him on the head going home.

"Clare, you were so silly with that Miss Remsen! She was laughing at you all the time."

"What are you talking about now?" he would chuckle, trying to remember which was Miss Remsen. He was not good at names, and pretty women were much the same to him anyhow. He was attentive and courtly to them by instinct, and Mother could see they felt flattered, but no one would have been as startled as Father if this had made complications. He thought of his marriage as one of those things that were settled. If any woman had really tried to capture him, she would have had a hard time. He was fully occupied with his business and his friends at the club, and he was so completely wrapped up in Mother that she was the one his eye followed. He liked to have a pretty woman next to him, as he liked a cigar or a flower, but if either a flower or a cigar had made demands on him, he would have been most disturbed.

The Dinner Table at Night (The Glass of Claret) by John Singer Sargent.
1884. Oil on canvas, 20¼ × 26¼". The Fine Arts Museums of San Francisco.
Gift of the Atholl McBean Foundation

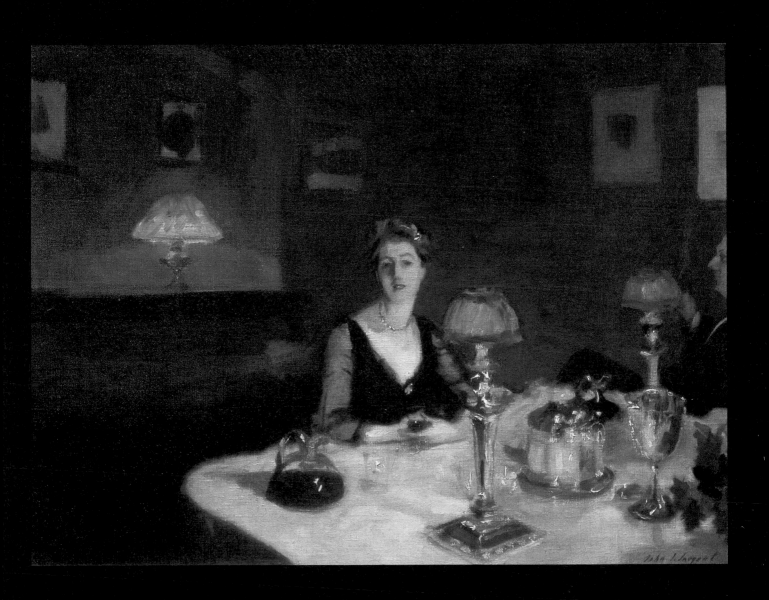

A Child's Guide to Parents

Ogden Nash

Children, I crave your kind forbearance;
Our topic for today is, Parents.

Parents are generally found in couples,
Except when divorce their number quadruples.

Mostly they're married to each other.
The female one is called the mother.

Paternal pride being hard to edit,
The male, or father, claims the credit,

But children, hark! Your mother would rather,
When you arrived, have been your father.

At last on common ground they meet:
Their child is sweetest of the sweet.

But burst not, babe, with boastful glee;
It is themselves they praise, not thee.

The reason father flatters thee, is—
Thou must be wonderful, aren't thou his?

And mother admires *her* offspring double,
Especially after all that trouble.

The wise child handles father and mother
By playing one against the other.

Don't! cries this parent to the tot;
The opposite parent asks, Why not?

Let baby listen, nothing loth,
And work impartially on both.

In clash of wills, do not give in;
Good parents are made by discipline;

Even a backward child can foil them,
If ever careful not to spoil them.

Does Daddy his precious glasses grudge?
Remember *you* are the proper judge.

Does Mummy remove the scissors hence?
Fail not to chide her impudence.

Woe to the weakling lad or lass
Who lets a slight or insult pass!

Woe to the spineless, falling heir unt-
To a headstrong, wayward parent!

But joy in heaping measure comes
To children whose parents are under their thumbs.

Christmas Card. Photograph by Elliott Erwitt. c. 1959

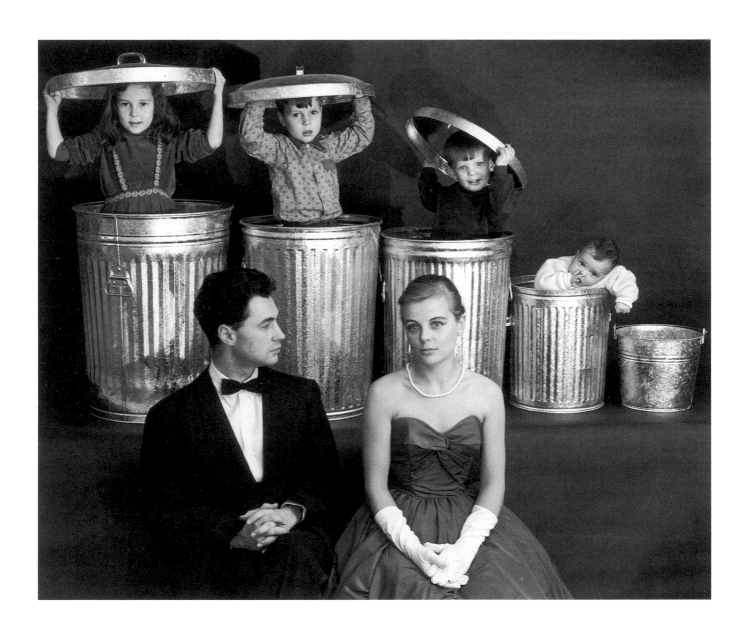

My Father's Song

Simon J. Ortiz

Wanting to say things,
I miss my father tonight.
His voice, the slight catch,
The depth from his thin chest,
The tremble of emotion
in something he has just said
to his son, his song.

> We planted corn one Spring at Acu—
> we planted several times
> but this one particular time
> I remember the soft damp sand
> in my hand.
>
> My father had stopped at one point
> to show me an overturned furrow;
> the plowshare had unearthed
> the burrow nest of a mouse
> in the soft moist sand.
>
> Very gently, he scooped tiny pink animals
> into the palm of his hand
> and told me to touch them.
> We took them to the edge
> of the field and put them in the shade
> of a sand moist clod.
>
> I remember the very softness
> of cool and warm sand and tiny alive mice
> and my father saying things.

For to Be a Farmer's Boy by
Winslow Homer. 1887. Watercolor
over pencil, 14 × 20″. The Art Institute
of Chicago. Anonymous gift in memory
of Edward Carson Waller

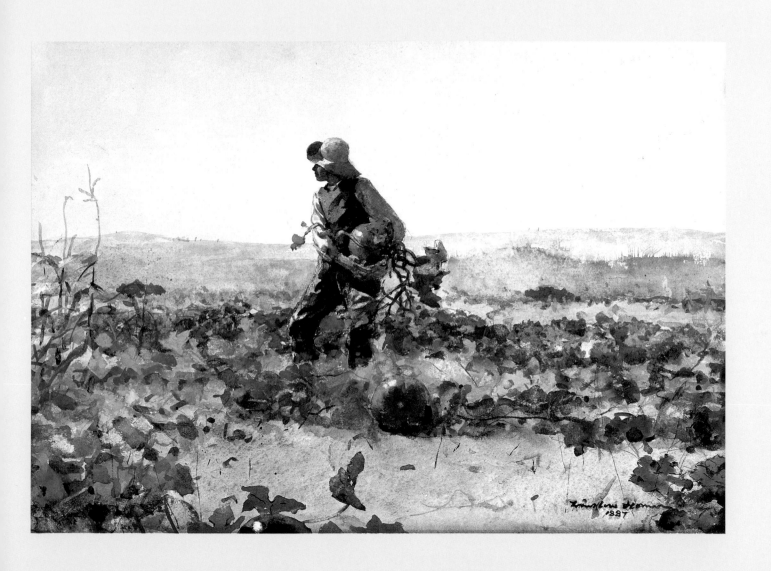

The Posing Is Over for the Moment

from a letter by Katherine Cassatt to her granddaughter Katherine, January 1885, Paris

I received the very pretty towel you embroidered for me & would have written sooner to thank you for it, but was so taken up with your father & Robbie that I wrote to nobody....

Your Aunt Mary had a little thing only two & a half years old to pose for her & it was funny to see her pretending to sew—she put in the needle & pulled it out exactly as if she was making stitches & exactly as she had seen her grandmother do it who was an embroideress by trade & by the way she posed so beautifully! I wish Robbie would do so half as well—I told him that when he begins to paint from life himself, he will have great remorse when he remembers how he teased his poor Aunt wriggling about like a flea— he laughs & says he isn't afraid of the remorse—he has just this instant opened the door to say "Aunt Mary would like you to come here Grandmother" & I know it is to try to make him pose a little as his father has just gone out....The posing is over for the moment & I come back to you....

Father's Story

Elizabeth Madox Roberts

We put more coal on the big red fire,
And while we are waiting for dinner to cook,
Our father comes and tells us about
A story that he has read in a book.

And Charles and Will and Dick and I
And all of us but Clarence are there.
And some of us sit on Father's legs,
But one has to sit on the little red chair.

And when we are sitting very still,
He sings us a song or tells a piece;
He sings Dan Tucker Went to Town,
Or he tells us about the golden fleece.

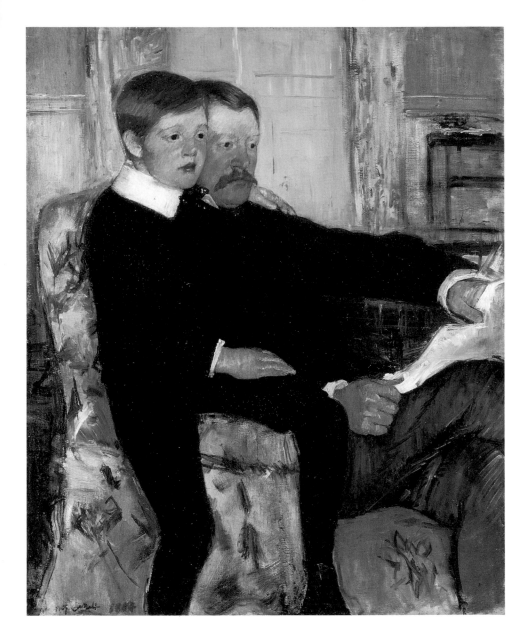

Portrait of Mr. Alexander Cassatt and His Son Robert by Mary Cassatt. 1884–85. Oil on canvas, 39 × 32″. Philadelphia Museum of Art, Pennsylvania. Wilstach Collection

He tells us about the golden wool,
And some of it is about a boy
Named Jason, and about a ship,
And some is about a town called Troy.

And while he is telling or singing it through,
I stand by his arm, for that is my place.
And I push my fingers into his skin
To make little dents in his big round face.

The Prodigal Son
The Gospel According to Saint Luke 15: 11–32

And he said, A certain man had two sons:

And the younger of them said to *his* father, Father, give me the portion of goods that falleth to *me*. And he divided unto them *his* living.

And not many days after the younger son gathered all together, and took his journey into a far country, and there wasted his substance with riotous living.

And when he had spent all, there arose a mighty famine in that land; and he began to be in want.

And he went and joined himself to a citizen of that country; and he sent him into his fields to feed swine.

And he would fain have filled his belly with the husks that the swine did eat: and no man gave unto him.

And when he came to himself, he said, How many hired servants of my father's have bread enough and to spare, and I perish with hunger!

I will arise and go to my father, and will say unto him, Father, I have sinned against heaven, and before thee,

And am no more worthy to be called thy son: make me as one of thy hired servants.

And he arose, and came to his father. But when he was yet a great way off, his father saw him, and had compassion, and ran, and fell on his neck, and kissed him.

And the son said unto him, Father, I have sinned against heaven, and in thy sight, and am no more worthy to be called thy son.

But the father said to his servants, Bring forth the best robe, and put *it* on him; and put a ring on his hand, and shoes on *his* feet:

And bring hither the fatted calf, and kill *it;* and let us eat, and be merry:

For this my son was dead, and is alive again; he was lost, and is found. And they began to be merry.

Now his elder son was in the field: and as he came and drew nigh to the house, he heard musick and dancing.

And he called one of the servants, and asked what these things meant.

And he said unto him, Thy brother is come; and thy father hath killed the fatted calf, because he hath received him safe and sound.

And he was angry, and would not go in: therefore came his father out, and intreated him.

And he answering said to *his* father, Lo, these many years do I serve thee, neither transgressed I at any time thy commandment: and yet thou never gavest me a kid, that I might make merry with my friends:

But as soon as this thy son was come, which hath devoured thy living with harlots, thou hast killed for him the fatted calf.

And he said unto him, Son, thou art ever with me, and all that I have is thine.

It was meet that we should make merry, and be glad: for this thy brother was dead, and is alive again; and was lost, and is found.

The Prodigal Son by Ruby Devol Finch. c. 1840–43. Watercolor on paper, 18¾ × 22¹¹⁄₁₆″. Abby Aldrich Rockefeller Folk Art Center, Williamsburg, Virginia

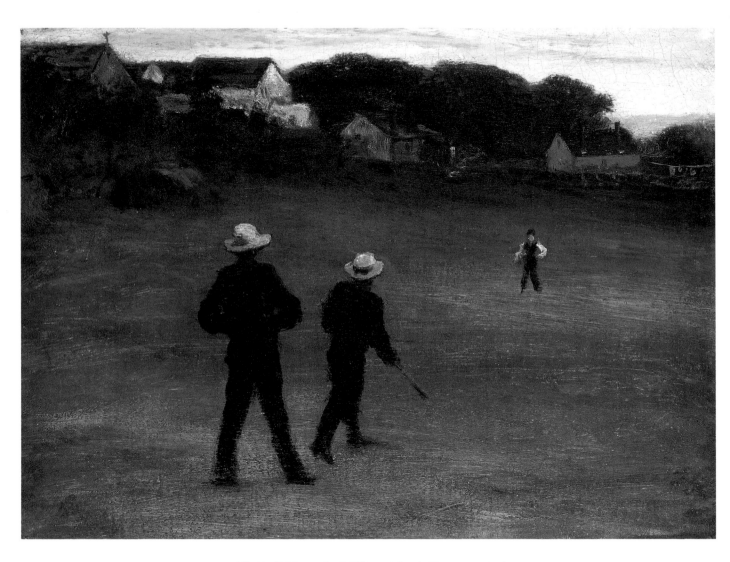

The Ball Players by William Morris Hunt. c. 1874.
Oil on canvas, 16 × 24". The Detroit Institute of
Arts. Gift of Mrs. John L. Gardner

Sign for My Father Who Stressed the Bunt

David Bottoms

On the rough diamond,
the hand-cut field below the dog lot and barn,
we rehearsed the strict technique
of bunting. I watched from the infield,
the mound, the backstop
as your left hand climbed the bat, your legs
and shoulders squared toward the pitcher.
You could drop it like a seed
down either base line. I admired your style,
but not enough to take my eyes off the bank
that served as our center-field fence.

Years passed, three leagues of organized ball,
no few lives. I could homer
into the garden beyond the bank,
into the left-field lot of Carmichael Motors,
and still you stressed the same technique,
the crouch and spring, the lead arm absorbing
just enough impact. The whole tiresome pitch
about basics never changing,
and I never learned what you were laying down.

Like a hand brushed across the bill of a cap,
let this be the sign
I'm getting a grip on the sacrifice.

He Was Born Out Doors
from *"One Hit, One Error, One Left"*

Ring Lardner

Stengels name aint Casey but that is just a nick name witch he says they call him that because he come from Kansas City but that don't make sense but some of the boys has got nick names like wear they come from like 1 of the pitchers Clyde Day but they call him Pea ridge Day because he come from a town name Pea ridge and he was the champion hog caller of Arkansaw and when he use to pitch in Brooklyn last yr he use to give a hog call after every ball he throwed but the club made him cut it out because the fans come down on the field every time he give a call and the club had to hire the champion of iowa to set up in the stand and call them back. Then there is a infielder Tommy Thompson but some times they call him Fresco and I thought it was because he come from Frisco but Stengel says his hole name is Al Fresco and his folks give him the name because he was born out doors like restrants where they got tables under a tree and 1 of the boys was asking if they call Wilson Hack because he was born in a hack but Stengel says it was 2 of them and they had to sell them to a junk dealer.

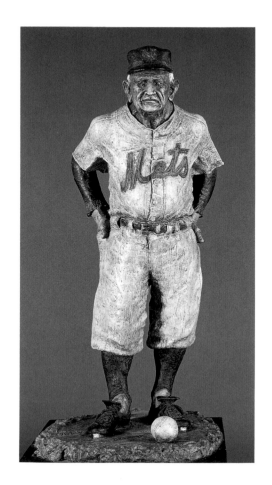

Charles Dillon (Casey) Stengel by Rhoda Sherbell. Polychromed bronze cast in 1981 from a 1965 plaster, height 44". National Portrait Gallery, Smithsonian Institution, Washington, D.C. Museum Purchase

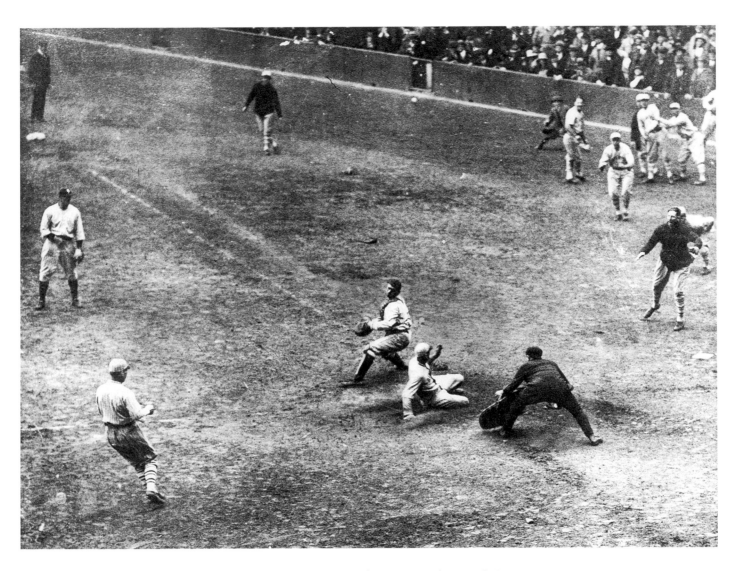

New York Giant Casey Stengel beats the Yankees at their own
game with an inside-the-park homer in the 1923 World Series.

My Dark Fathers

Brendan Kennelly

My dark fathers lived the intolerable day
Committed always to the night of wrong,
Stiffened at the hearthstone, the woman lay,
Perished feet nailed to her man's breastbone.
Grim houses beckoned in the swelling gloom
Of Munster fields where the Atlantic night
Fettered the child within the pit of doom,
And everywhere a going down of light.

And yet upon the sandy Kerry shore
The woman once had danced at ebbing tide
Because she loved flute music—and still more
Because a lady wondered at the pride
Of one so humble. That was long before
The green plant withered by an evil chance;
When winds of hunger howled at every door
She heard the music dwindle and forgot the dance.

Such mercy as the wolf receives was hers
Whose dance became a rhythm in a grave,
Achieved beneath the thorny savage furze
That yellowed fiercely in a mountain cave.
Immune to pity, she, whose crime was love,
Crouched, shivered, searched the threatening sky,
Discovered ready signs, compelled to move
Her to her innocent appalling cry.

Skeletoned in darkness, my dark fathers lay
Unknown, and could not understand
The giant grief that trampled night and day,
The awful absence moping through the land.
Upon the headland, the encroaching sea
Left sand that hardened after tides of Spring,
No dancing feet disturbed its symmetry
And those who loved good music ceased to sing.

Since every moment of the clock
Accumulates to form a final name,
Since I am come of Kerry clay and rock,
I celebrate the darkness and the shame
That could compel a man to turn his face
Against the wall, withdrawn from light so strong
And undeceiving, spancelled in a place
Of unapplauding hands and broken song.

Immigrant Daughter's Song

Mary Ann Larkin

All gone,
the silver-green silk of time
winding down centuries
of custom and kinship
the pouring of the sea
the stars, bright pictures
on the slate of night,
the moon stamping forever
the spire of the church
on the sand,
bird-song, wind-song, mother-song
Even time itself changed
to a ticking, a dot on a line

Customs of grace and gentleness gone
name-saying
and knowing
who begat who
and when and where
and who could work
and who could sing
and who would pray
and who would not
and where the fish ran
and the wild plums hid
and how the old mothers
fit their babies' fingers
to the five-flowered hollows
of blue ladyfingers
And whose father fought whose
with golden swords
a thousand years ago
at Ballyferriter
on the strand below the church

All gone
changed from a silken spool
 unwinding
to rooms of relics and loss
behind whose locked doors
I dream
not daring to wake

The Irish Famine by George Frederick
Watts. 1849–50. Oil on canvas, 71 × 78″.
Watts Gallery, Compton, England

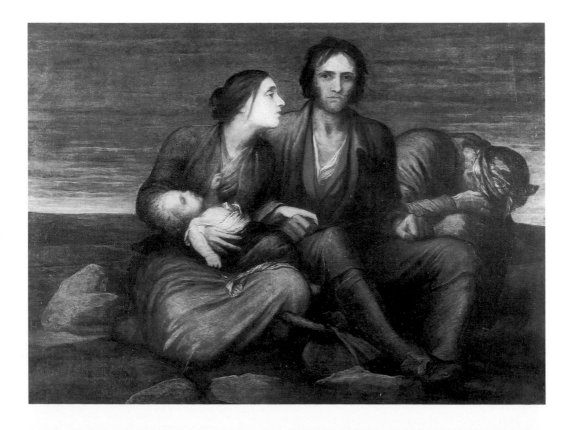

The Men at the Mill
from *Spartina*

John Casey

When he was eight he used to collect the men's hot lunches from all the wives—the Irish workers lived at the top of the hill in company houses—and he'd load all the lunch pails in a barrel he'd nailed to his sled, and just as the noon whistle blew he'd shoot down the hill, his legs wrapped around the barrel, his face freezing in the wind where he peeped around. He'd coast up to the door of the mill, and the men picked out their lunch pails and let him come inside to get warm, and they'd all talk a blue streak. There was no talking allowed during work, so they were all busting. He heard their voices in his dreams—most of them still had brogues in those days. And he remembers them not being able to stand still after being stuck at the machines. They'd arm-wrestle and dance and challenge each other to walk on their hands. My father's father was famous for being able to jump over a dye vat from a standing start. My father saw him do it. He'd crouch down and disappear behind the vat and suddenly there he was flying through the air. I'd always thought the mills must have been hell, but when my father was dying it all seemed paradise to him. The way he talked, it was as though he'd never known anything since. He'd wake up from his nap and tell me about his sled shooting down the hill.

End of the Day by Charles Burchfield. 1938. Watercolor, 28 × 48″. Pennsylvania Academy of Fine Arts, Philadelphia. Joseph E. Temple Fund

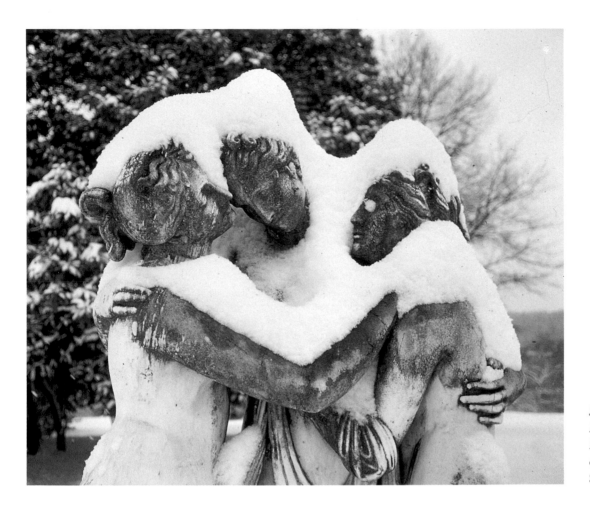

Snow-covered Sculpture in Maymont Park, Richmond, Virginia. c. 1989. Henley & Savage Photography

Winter's Not Gone Yet
from *King Lear*

William Shakespeare

Winter's not gone yet, if the wild geese fly that way.
 Fathers that wear rags
 Do make their children blind,
 But fathers that bear bags
 Shall see their children kind.
 Fortune, that arrant whore,
 Ne'er turns the key to th'poor.
But for all this, thou shalt have as many dolours for thy daughters
as thou canst tell in a year.

All the Children Were Against Their Father
from *Sons and Lovers*

D. H. Lawrence

All the children, but particularly Paul, were peculiarly *against* their father, along with their mother. Morel continued to bully and to drink. He had periods, months at a time, when he made the whole life of the family a misery. Paul never forgot coming home from the Band of Hope one Monday evening and finding his mother with her eye swollen and discoloured, his father standing on the hearthrug, feet astride, his head down, and William, just home from work, glaring at his father. There was a silence as the young children entered, but none of the elders looked round.

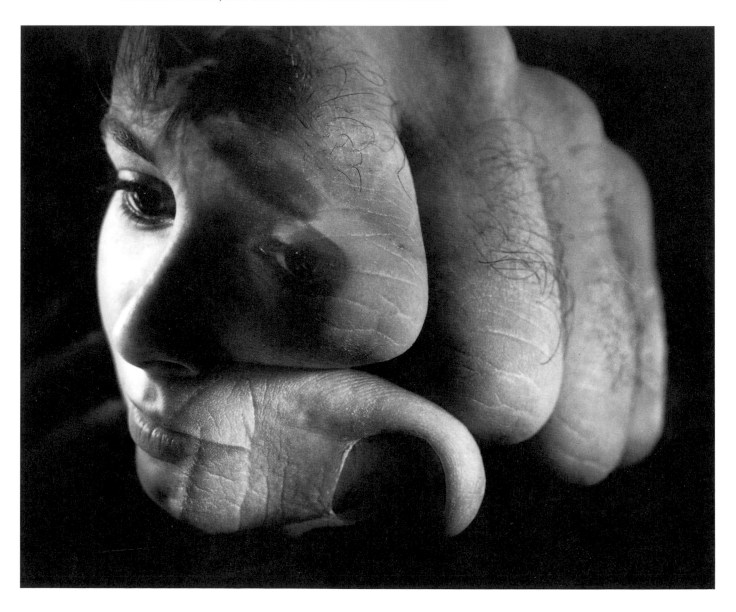

William was white to the lips, and his fists were clenched. He waited until the children were silent, watching with children's rage and hate; then he said:

"You coward, you daren't do it when I was in."

But Morel's blood was up. He swung round on his son. William was bigger, but Morel was hard-muscled, and mad with fury.

"Dossn't I?" he shouted. "Dossn't I? Ha'e much more o' thy chelp, my young jockey, an' I'll rattle my fist about thee. Ay, an' I sholl that, dost see."

Morel crouched at the knees and showed his fist in an ugly, almost beast-like fashion. William was white with rage.

"Will yer?" he said, quiet and intense. "It 'ud be the last time, though."

Morel danced a little nearer, crouching, drawing back his fist to strike. William put his fists ready. A light came into his blue eyes, almost like a laugh. He watched his father. Another word, and the men would have begun to fight. Paul hoped they would. The three children sat pale on the sofa.

"Stop it, both of you," cried Mrs. Morel in a hard voice. "We've had enough for *one* night. And *you*," she said, turning on to her husband, "look at your children!"

Morel glanced at the sofa.

"Look at the children, you nasty little bitch!" he sneered. "Why, what have *I* done to the children, I would like to know? But they're like yourself; you've put 'em up to your own tricks and nasty ways—you've learned 'em in it, you 'ave."

She refused to answer him. No one spoke. After a while he threw his boots under the table and went to bed.

"Why didn't you let me have a go at him?" said William, when his father was upstairs. "I could easily have beaten him."

"A nice thing—your own father," she replied.

"'*Father!*'" repeated William. "Call him my father!"

"Well, he is—and so—"

"But why don't you let me settle him? I could do, easily."

"The idea!" she cried. "It hasn't come to *that* yet."

"No," he said, "it's come to worse. Look at yourself. *Why* didn't you let me give it to him?"

"Because I couldn't bear it, so never think of it," she cried quickly.

And the children went to bed, miserably.

Symbolic Mutation by Jerry Uelsmann. 1961. Combination print.
Courtesy the artist

Quite Obvious What the Father Was Doing
from *"The Significance of the Father in the Destiny of the Individual"*
C. G. Jung

In our case, it is quite obvious what the father was doing, and why he wanted to marry his daughter to this brutish creature: he wanted to keep her with him and make her his slave for ever. What he did is but a crass exaggeration of what is done by thousands of so-called respectable, educated parents, who nevertheless pride themselves on their progressive views. The fathers who criticize every sign of emotional independence in their children, who fondle their daughters with ill-concealed eroticism and tyrannize over their feelings, who keep their sons on a leash or force them into a profession and finally into a "suitable" marriage, the mothers who even in the cradle excite their children with unhealthy tenderness, who later make them into slavish puppets and then at last ruin their love-life out of jealousy: they all act no differently in principle from this stupid, boorish peasant. They do not know what they are doing, and they do not know that by succumbing to the compulsion they pass it on to their children and make them slaves of their parents and of the unconscious as well. Such children will long continue to live out the curse laid on them by their parents, even when the parents are long since dead. "They know not what they do." Unconsciousness is the original sin.

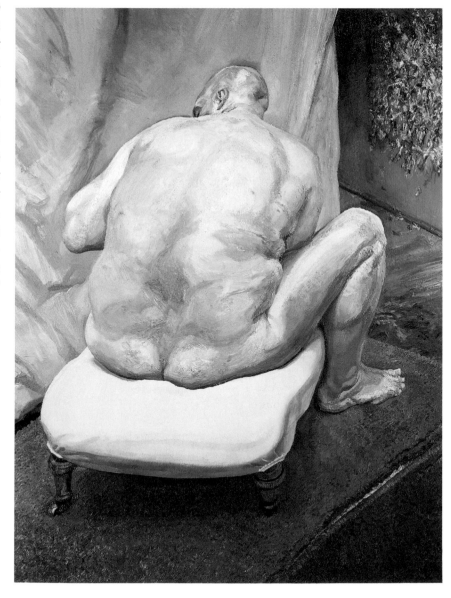

Naked Man, Back View by Lucien Freud. 1991–92. Oil on canvas, 72 × 54". The Metropolitan Museum of Art, New York. Purchase, Lila Acheson Wallace Gift, 1993

62

Lizzie Borden

Anonymous

Lizzie Borden took an axe
And gave her mother forty whacks;
When she saw what she had done
She gave her father forty-one.

Kitchen Scene, Yellow House by Bill
Traylor. 1939–42. Pencil and colored
pencil on cardboard, 21 × 14".
The Metropolitan Museum of Art,
New York. Purchase, Anonymous
Gift, 1992

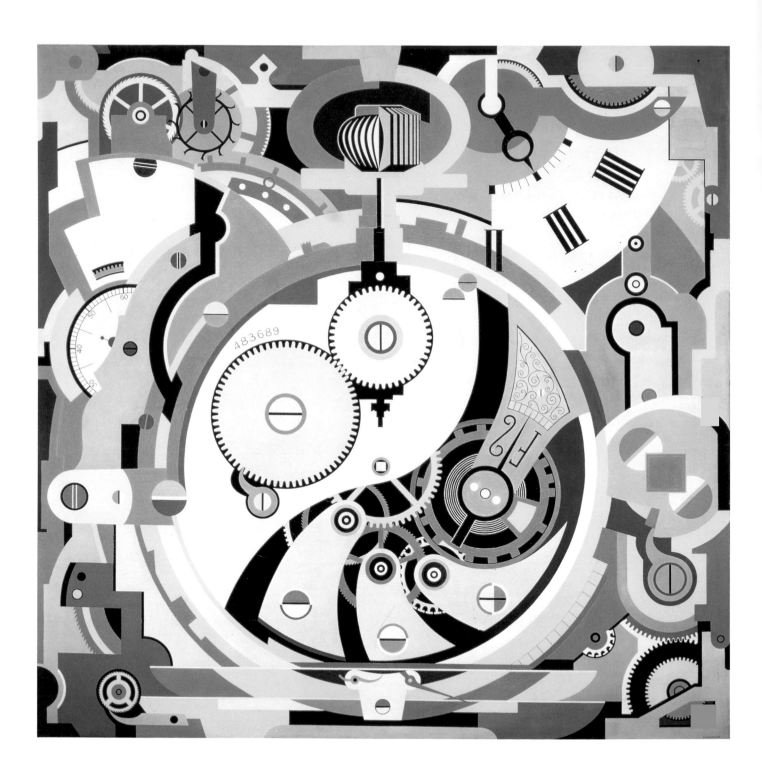

Zelda Was Always My Child

from a letter to Sarah Murphy by F. Scott Fitzgerald

I am moving Zelda to a sanitarium in Asheville—she is no better, though the suicidal cloud has lifted.—I thought over your Christian Science idea and finally decided to try it but the practitioner I hit on wanted to begin with "absent treatments," which seemed about as effectual to me as the candles my mother keeps constantly burning to bring me back to Holy Church—so I abandoned it. Especially as Zelda now claims to be in direct contact with Christ, William the Conqueror, Mary Stuart, Apollo and all the stock paraphernalia of insane-asylum jokes. Of course it isn't a bit funny but after the awful strangulation episode of last spring I sometimes take refuge in an unsmiling irony about the present *exterior* phases of her illness. For what she has really suffered, there is never a sober night that I do not pay a stark tribute of an hour to in the darkness. In an odd way, perhaps incredible to you, she was always my child (it was not reciprocal as it often is in marriages), my child in a sense that Scottie isn't, because I've brought Scottie up hard as nails (perhaps that's fatuous, but I *think* I have). Outside of the realm of what you called Zelda's "terribly dangerous secret thoughts" I was her great reality, often the only liaison agent who could make the world tangible to her—

The only way to show me you forgive this great outpouring is to write me about yourselves. Some night when you're not too tired, take yourself a glass of sherry and write me as lovely and revealing {a} letter as you did before. Willy-nilly we are still in the midst of life and all true correspondence is necessarily sporadic but a letter from you or Gerald always pulls at something awfully deep in me. I want the best news, but in any case I want to know.

With dearest affection to you all,
Scott

Watch by Gerald Murphy. 1925. Oil on canvas, 78½ × 78⅞". Dallas Museum of Art, Texas. Foundation for the Arts Collection, gift of the artist

Is It Youth? No; Not Only Youth
from *Fathers and Sons*

Ivan Turgenev

Half an hour later Nikolai Petrovitch went into the garden to his favourite arbour. He was overtaken by melancholy thoughts. For the first time he realised clearly the distance between him and his son; he foresaw that every day it would grow wider and wider. In vain, then, had he spent whole days sometimes in the winter at Petersburg over the newest books; in vain had he listened to the talk of the young men; in vain had he rejoiced when he succeeded in putting in his word too in their heated discussions. "My brother says we are right," he thought, "and apart from all vanity, I do think myself that they are further from the truth than we are, though at the same time I feel there is something behind them we have not got, some superiority over us.... Is it youth? No; not only youth. Doesn't their superiority consist in there being fewer traces of the slaveowner in them than in us?"

Nikolai Petrovitch's head sank despondently, and he passed his hand over his face.

"But to renounce poetry?" he thought again; "to have no feeling for art, for nature..."

And he looked round, as though trying to understand how it was possible to have no feeling for nature.

Student by Nikolai Aleksandrovich Yaroshenko. 1881. Oil on canvas, 34¼ × 23⅝". The State Tretyakov Gallery, Moscow

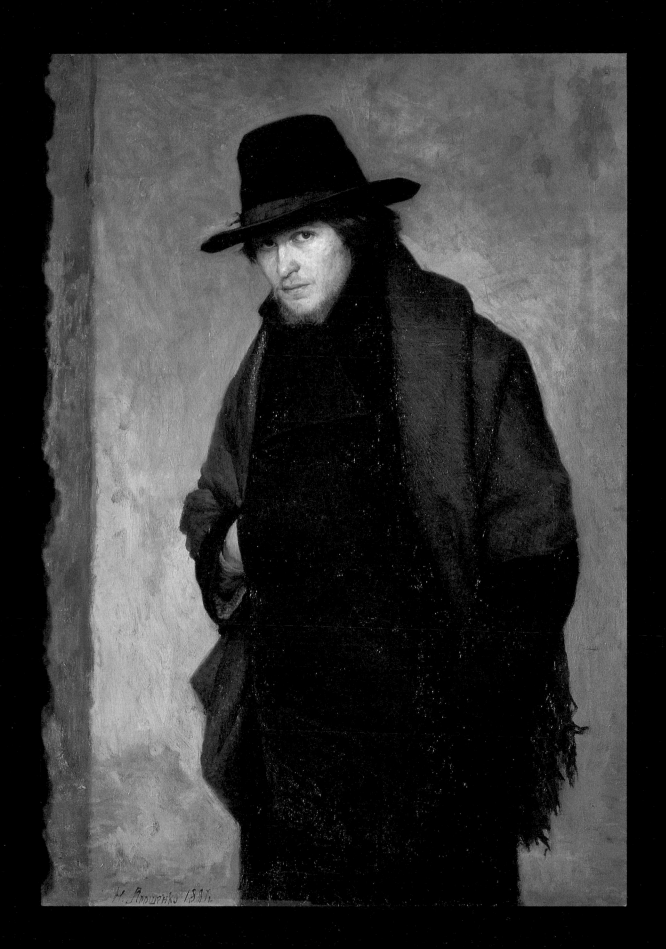

Divorce, Etc.

Judith Kroll

There is a house
at the end of a street—

spacious calm light

with a deep porch all around,
and a heart that is sound.

Stories gather on the sills at evening,
friendly adventures ending in home.

Lamps ripen in impending dusk,
candle-flames of souls in chorus,
a single note piercing every one—

the fireplace sang,
wind moved in our branches
as in summer, which trades daylight
for the glow of innerness,
candle-glow of bodiless souls
(a single note ignites them, rumor
drenching the crowd).

The house had everything.
On one side, wooded—a solitude
wounded by absence. And healed.

One side facing neighbors,
a peaceful street

like the flesh of a pregnant woman
whose symphony of cells
spins love from her body
(a single fate unites them),

a chain electrocution,
the family herded off
by the killer:

they know he will kill them,
know what they might do,
yet are never quite ready to act.

And upstairs, near the window
where sunlight gilds a child's collection of shells—

perfection of spirals,
elated forms!—
 whoever wonders what their lives were like,
 the lives of these creatures that lived
 inside such beauty?

Self-Portrait by Günter Grass. 1972. Etching, 7¾ × 9⅝". Arents Collections, The New York Public Library, Astor, Lenox and Tilden Foundations

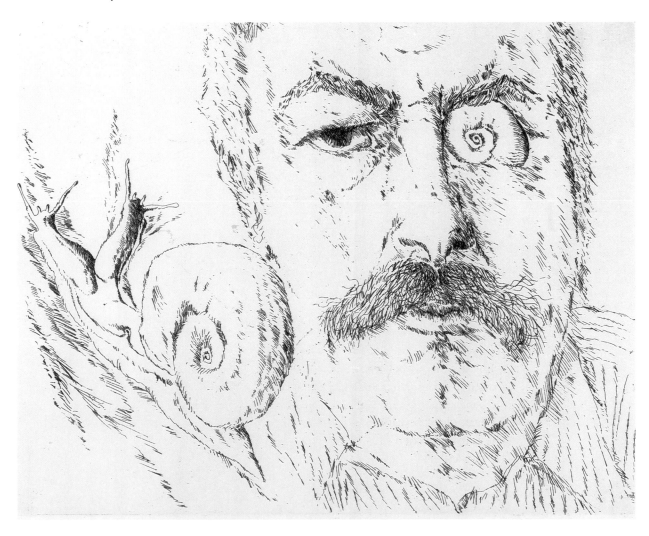

Another Kind of Country

Charles Sullivan

He could see things
invisible to me
in any kind of country
that he found—once
when the river was still
unfamiliar, he asked me why
the sky had run aground, but
looking past him, I could only see
a man, a boy, not unlike us
yet most unlike, their posture
softened by the underwater light,
their wishes sure to be fulfilled
until the fish explored their heads
and read their minds.

Then the question blew away,
and I was in another kind
of country, I could see things
invisible to him that blinded me—
his mother's imitation of a smile,
her hazel eyes enraged while she
denied it, the clothes she wore
an accusation of a crime for which
the sentences are taking too much time.

Now I climb the same uneven stairs,
remembering the words, the other things
we couldn't find together. Somehow
as I tried to see flamingoes cross
our covered bridge, she became invisible
to me, somewhere in the shadow of that ridge
I lost her love. Whatever might have been,
this was not her country, and despite
the shining promise of a few old farms
at night, it isn't mine. I'm getting cold
beside the window, tired of looking out.

Leaper with Snake by Mary Frank. 1985.
Monoprint on paper, 27⅞ × 36". Courtesy
Midtown Payson Galleries, New York

My son has seen more winter nights
than this on his computer screen,
and so he writes the universal colors
of such music as the dead rehearse
for skulls and heads and nimble bones
to dance to. He's alone behind his mask,
he wouldn't answer if I asked him
how to find a country of astounding
elephants, or cloudy castles rising
over ordinary towns, or traces
of young robin hoods with snowflakes
on their faces, riding slowly
through the woods beyond our house.

Man's Pride

F. Ricardo Gomez

Long days of loneliness, and plight
Stinking brown sweat filtering through a mass of
uncut hair:
Entering sheepishly into the corners of my red,
sun-swollen eyes

Enduring the burning, itching sensations so as not
to break my rhythm nor my stride
Unable to break the hypnotic spell
Developed to black-out the boiling sun, and forget
the years of stooping—
Like a loyal hound, instinctively my rough,
calloused hands,
search for #1's amidst a field of ripened pumpkins.
I hear growers convincing each other as I near the
tractor

These people want no other kind of work
They were born to wander, to live and die happily
wrestling fruits from stems and vines—
Reacting invisibly to the outsiders in camp—
Wondering why and what they offered in exchange
to photograph our lives—
Others talk of escaping our chains of coolie wages—
Through a strike—
Listening at first, because I know I wear trousers
that once belonged to one of them—
I see my son in winter clothes in July—
I try to understand their talk of opportunities
Although none had ever come—
Except to some— Crew leaders—
My fear is soon replaced by rage;
As I see others like myself long denied the right to
live
Like other human beings—
So often are trapped by accepting
superficial contracts
And grower advice—
I join in a Huelga—

I am still stooping and sweating in the sun
But now I have pride
I am now paid as a man
Gone are the days of the timid, trained hound
My child will not understand

Father

Pablo Neruda

The brusque father comes back
from his trains:
we could pick out
his train whistle
cutting the rain,
a locomotive's
nocturnal lament
an unplaceable howl
in the dark.
Later,
the door started trembling.
Wind entered
in gusts with my father;
and between the two advents, footfalls and tensions,
the house
staggered,
a panic of doorways
exploded with a dry
sound of pistols,
stairs groaned
and a shrill voice
nagged hatefully on
in the turbulent
dark. Rain
flooded the roof tops,
the world drowned
by degrees, there
was only the wind's sound
trading blows with the rain.

Still, he was punctual.
Commanding his train in the freeze of the morning,
the sun barely
aloft in the sky, he was there with his beard
and his green and red
signal flags, lanterns ready,
the engine-coal blazing like hellfire,
the Station House showing coach after coach through the fog—
to settle his debt with geography.

Farm Workers Leader Cesar Chavez. Photograph by Larry Armstrong. 1978

Railroader, land-sailor
touching ports with no seacoasts
—whistle stops in the woods—the train races on
brakeless as nature
in its terrestrial voyage.
Not till it rests all
its length of the rails and friends greet
and come in, do the doors of my infancy open:
the table is shaken again
by a railroader's fist
knocking thick glass together, a brotherhood
glowing,
flashing sparks
from the eyes in the wine.

Poor, durable father,
there on the axle of life,
virile in friendships, your cup overflowing:
the whole of your life was a headlong militia;
between daybreaks and roadbeds,
comings and goings, you lived on the double.
Then, on the rainiest day of them all,
the conductor, José del Carmen Reyes,
boarded his death train and has not come back to us since.

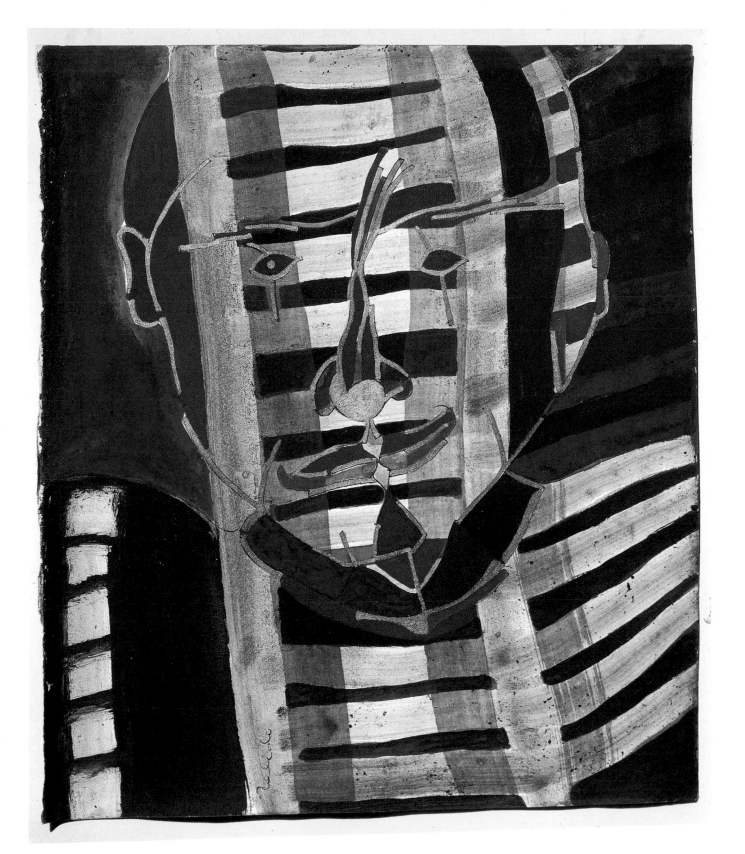

The Origin of the Parental and Filial Affections
from *The Descent of Man, and Selection in Relation to Sex*
Charles Darwin

The feeling of pleasure from society is probably an extension of the parental or filial affections, since the social instinct seems to be developed by the young remaining for a long time with their parents; and this extension may be attributed in part to habit, but chiefly to natural selection. With those animals which were benefited by living in close association, the individuals which took the greatest pleasure in society would best escape various dangers, while those that cared least for their comrades, and lived solitary, would perish in greater numbers. With respect to the origin of the parental and filial affections, which apparently lie at the base of the social instincts, we know not the steps by which they have been gained; but we may infer that it has been to a large extent through natural selection.

Horace Darwin, Son of Charles Darwin by Julia Margaret Cameron. 1868. Albumen-silver print from a glass negative, 13¹¹⁄₁₆ × 10¾". The Museum of Modern Art. Gift of Shirley C. Burden, by exchange

See What It Is to Be Well Trained
from *More Letters of Charles Darwin*

See what it is to be well trained. Horace said to me yesterday, "If every one would kill adders they would come to sting less." I answered: "Of course they would, for there would be fewer." He replied indignantly: "I did not mean that; but the timid adders which run away would be saved, and in time they would never sting at all." Natural selection of cowards!

He May Have Been Just a Boy
from *All the King's Men*

Robert Penn Warren

Tom Stark may have been just a boy, as the Boss said, but he had had a good deal to do with the way things were going. But, then, the Boss had had a good deal to do, I suppose, with making Tom what Tom was. So there was a circle in the proof, and the son was merely an extension of the father, and when they glared at each other it was like a mirror looking into a mirror. As a matter of fact they did look alike, the same cock to the head on the shoulders, the same forward thrust of the head, the same sudden gestures. Tom was a trained-down, slick-faced, confident, barbered version of what the Boss had been a long time back when I first knew him. The big difference was this: Back in those days the Boss had been blundering and groping his unwitting way toward the discovery of himself, of his great gift, wearing his overalls that bagged down about the seat, or the blue serge suit with the tight, shiny pants, nursing some blind and undefined compulsion within him like fate or a disease. Now Tom wasn't blundering and groping toward anything, and certainly not toward a discovery of himself. For he knew that he was the damnedest, hottest thing there was. Tom Stark, All American, and there were no flies on him. And no overalls bagged down about his snake hips and pile-driver knees. No, he would stand in his rubber-soled saddle shoes in the middle of the floor with a boxer's stance, the gray-striped sport coat draped over his shoulders, the top button of his heavy-weave white shirt unbuttoned, the red wool tie tied in a loose hanging knot as big as your fist under his bronze-looking throat, jerked over to one side though, and his confident eyes would rove slowly over the joint and his slick, strong, brown jaw would move idly over the athlete's chewing gum. You know how athletes chew gum. Oh, he was the hero, all right, and he wasn't blundering or groping. He knew what he was.

He knew he was good. So he didn't have to bother to keep all the rules. Not even the training rules. He could deliver anyway, he told his father, so what the hell? But he did it once too often. He and Thad Mellon, who was a substitute tackle, and Gup Lawson, who was a regular guard, did themselves proud one Saturday night after the game out at a roadhouse. They might have managed very well, if they hadn't got into a fight with some yokels who didn't know or care much about football and who resented having their girls fooled with. Gup Lawson took quite a beating from the yokels and went to the hospital and was out of football for several weeks. Tom and Thad didn't get more than a few punches before the crowd broke up the fight. But the breach of rules was dumped rather dramatically into the lap of Coach Billie Martin. It got into one of the papers. He suspended Tom Stark and Thad Mellon. That definitely changed the betting odds for the Georgia game for the following Saturday, for Georgia was good that year, and Tom Stark was the local edge.

The Boss took it like a man. No kicking and screaming even when Georgia wound up the half with the score seven to nothing. As soon as the whistle blew he was on his feet. "Come on," he said to me, and I knew he was on his way to the field house. I trailed him

down there, and leaned against the doorjamb and watched it. Back off on the field there was the band music now. The band would be parading around with the sunshine (for this was the first of the afternoon games, now that the season was cooling off) glittering on the brass and on the whirling gold baton of the leader. Then the band, way off there, began to tell Dear Old State how we loved her, how we'd fight, fight, fight for her, how we'd die for her, how she was the mother of heroes. Meanwhile the heroes, pretty grimy and winded, lay around and got worked over.

To Lou Little

Jack Kerouac

Lou, my father thought you put him down
 and said he didnt like you

He thought he was too shabby for your
 office; his coat had got so

And his hair he'd comb and come
 into an employment office with me

And have me speak alone with the man
 for the two of us, then sigh

And repented we home; where
 sweet mother put out the pie

 anyway

In my first game I ran like mad
 at Rutgers, Cliff wasnt there;

He didnt believe what he read
 in the Spectator, 'Who's this Jack?'

So I come in on the St Benedicts game
 not willing to be caught by them
 bums

I took off the kickoff right straight at
 the gang, and lalooza'd around

To the pastafazoola five yard line,
 you were there, you remember

We didnt make first down; and I
 took the punt and broke my leg

And never said anything, and ate hot
 fudge sundaes & steaks in the
 Lion's Den

American Football by W. Eugene Smith. 1941. Gelatin silver print. Collection the Center for Creative Photography, The University of Arizona, Tucson. © The Heirs of W. Eugene Smith, Courtesy Black Star

If You Will Let Your Whiskers Grow

letter by Grace Bedell to Abraham Lincoln

N Y

Hon A B Lincoln Westfield Chatauque Co

Dear Sir Oct 15 1860

My father has just home from the fair and brought home your picture and Mr. Hamlin's. I am a little girl only eleven years old, but want you should be President of the United States very much so I hope you wont think me very bold to write to such a great man as you are. Have you any little girls about as large as I am if so give them my love and tell her to write me if you cannot answer this letter. I have got 4 brother's and part of

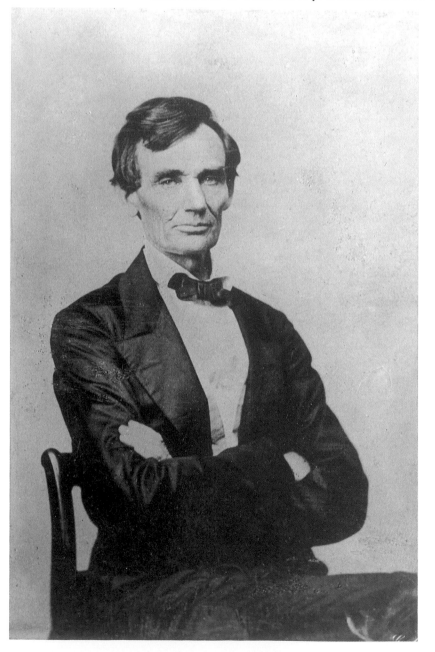

them will vote for you any way and if you will let your whiskers grow I will try and get the rest of them to vote for you. you would look a great deal better for your face is so thin. All the ladies like whiskers and they would tease their husband's to vote for you and then you would be President. My father is going to vote for you and if I was a man I would vote for you but I will try and get every one to vote for you that I can. I think that rail fence around your picture makes it look very pretty. I have got a little baby sister she is nine weeks old and is just as cunning as can be. When you direct your letter dirct to Grace Bedell Westfield Chatauque County New York.

I must not write any more. Answer this letter right off. Goodbye
Grace Bedell

Abraham Lincoln's last beardless portrait, August 13, 1860. Photograph. Courtesy Louis A. Warren Lincoln Library and Museum, Fort Wayne, Indiana

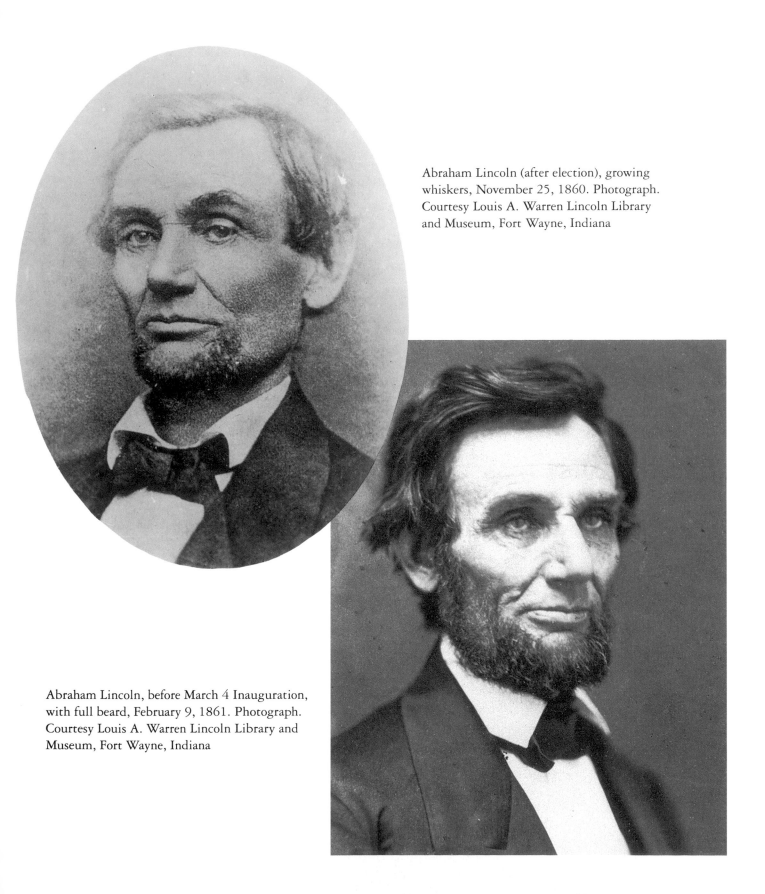

Abraham Lincoln (after election), growing
whiskers, November 25, 1860. Photograph.
Courtesy Louis A. Warren Lincoln Library
and Museum, Fort Wayne, Indiana

Abraham Lincoln, before March 4 Inauguration,
with full beard, February 9, 1861. Photograph.
Courtesy Louis A. Warren Lincoln Library and
Museum, Fort Wayne, Indiana

Father and Mother Were About Equally Helpless
from *The Education of Henry Adams*

Henry Brooks Adams

As far as outward bearing went, such a family of turbulent children, given free rein by their parents, or indifferent to check, should have come to more or less grief. Certainly no one was strong enough to control them, least of all their mother, the queen-bee of the hive, on whom nine-tenths of the burden fell, on whose strength they all depended, but whose children were much too self-willed and self-confident to take guidance from her, or from any one else, unless in the direction they fancied. Father and mother were about equally helpless. Almost every large family in those days produced at least one black sheep, and if this generation of Adamses escaped, it was as much a matter of surprise to them as to their neighbors. By some happy chance they grew up to be decent citizens, but Henry Adams, as a brand escaped from the burning, always looked back with astonishment at their luck. The fact seemed to prove that they were born, like birds, with a certain innate balance. Home influences alone never saved the New England boy from ruin, though sometimes they may have helped to ruin him; and the influences outside of home were negative. If school helped, it was only by reaction. The dislike of school was so strong as to be a positive gain. The passionate hatred of school methods was almost a method in itself. Yet the day-school of that time was respectable, and the boy had nothing to complain of. In fact, he never complained. He hated it because he was here with a crowd of other boys and compelled to learn by memory a quantity of things that did not amuse him. His memory was slow, and the effort painful. For him to conceive that his memory could compete for school prizes with machines of two or three times its power, was to prove himself wanting not only in memory, but flagrantly in mind. He thought his mind a good enough machine, if it were given time to act, but it acted wrong if hurried. Schoolmasters never gave time.

Henry Adams in His Study by Mabel Hooper La Farge. c. 1894. Watercolor on paper, 6½ × 9⅜″. Houghton Library, Harvard University

Something Old and Intimate
from *The Frontiers of Love*

Diana Chang

She would walk down Third Avenue and stare unseeing at all the antique stores, just to be near something ancient—a small ruin of candelabra, a small heap of moldering beauty, something old and patina-ed to remind her of China, something old and intimate and taking up room for no other reason than for its own inefficient self.

She had been homesick then, but she had also been an adolescent, and thought not always of home, but also of the air, or the thing that could not be seen, touched or found on land or sea. She wanted the day to be special, not only for herself, but for everyone, and she wanted this thing, this thing that no one had ever seen, heard of or dreamed of before, to be waiting for her as she left the front stoop. It must behave in a way true to itself, but it must behave magnificently. And the thing and she would know, would simply recognize each other, and there! she and the thing—which was air, man, earth and idea, all wrapped up into one unity—would recognize each other, and that would be the beginning, the end and the middle of her life. Of course, needless to say, it never happened; nothing was waiting at the front stoop, and her disappointment, the name she gave to her disappointment was America.

Merchant Holding a Wine Skin Vessel by an unknown Chinese artist. Tang dynasty, 619–906 A.D. Pottery with san ts'ai (three color) glaze, height 14⅝", width 10", diameter 6½". Seattle Art Museum. Eugene Fuller Memorial Collection

Look at the Brute!
from *Heartbreak House*

George Bernard Shaw

MRS HUSHABYE. Have you no heart? Have you no sense? Look at the brute! Think of poor weak innocent Ellie in the clutches of this slavedriver, who spends his life making thousands of rough violent workmen bend to his will and sweat for him: a man accustomed to have great masses of iron beaten into shape for him by steam-hammers! to fight with women and girls over a halfpenny an hour ruthlessly! a captain of industry, I think you call him, dont you? Are you going to fling your delicate, sweet, helpless child into such a beast's claws just because he will keep her in an expensive house and make her wear diamonds to shew how rich he is?

MAZZINI [*staring at her in wide-eyed amazement*] Bless you, dear Mrs Hushabye, what romantic ideas of business you have! Poor dear Mangan isnt a bit like that.

MRS HUSHABYE [*scornfully*] Poor dear Mangan indeed!

MAZZINI. But he doesnt know anything about machinery. He never goes near the men: he couldnt manage them: he is afraid of them. I never can get him to take the least interest in the works: he hardly knows more about them than you do. People are cruelly unjust to Mangan: they think he is all rugged strength just because his manners are bad.

MRS HUSHABYE. Do you mean to tell me he isnt strong enough to crush poor little Ellie?

MAZZINI. Of course it's very hard to say how any marriage will turn out; but speaking for myself, I should say that he wont have a dog's chance against Ellie. You know, Ellie has remarkable strength of character. I think it is because I taught her to like Shakespear when she was very young.

Mr. George Bernard
Shaw - Capitalist

87

They Have Cast Off Their Father
from *Old Goriot*

Honoré de Balzac

"They have cast off their father," Eugène repeated.

"Yes, indeed, their own father," replied the Viscountess, "the father, a father, a good father, who, they say, gave each of them five or six hundred thousand francs to ensure their happiness by marrying them well, and kept only eight or ten thousand livres a year for

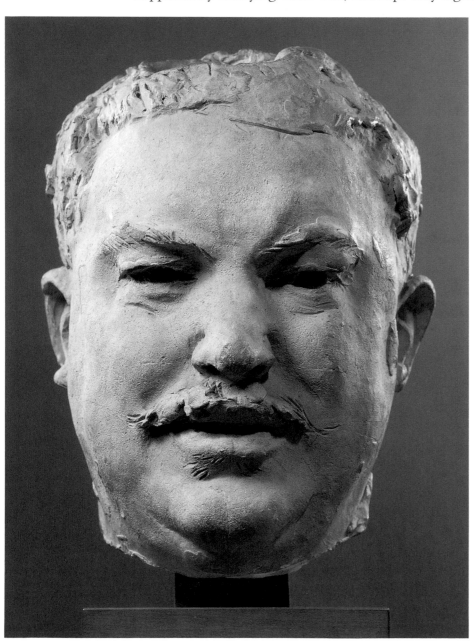

himself, believing that his daughters would remain his daughters, that in their new lives he had created two new existences for himself, gained two houses where he would be made much of and adored. Within two years his sons-in-law had banished him from their company as if he were the lowest of social outcasts."

Tears sprang to Eugène's eyes. He had recently been exposed to the pure and holy influence of family affection; he was still held by the spell of youthful beliefs; and this was only his first day on the battle-field of Parisian civilization. True emotion is so infectious that for a moment these three persons looked at one another in silence.

"Ah! yes, indeed," said Madame de Langeais, "it seems very terrible, and yet we see it every day. Isn't there a reason for that? Tell me, my dear, have you ever considered what a son-in-law is? A son-in-law is a man for whom we shall rear, you and I, a dear little creature to whom affection binds us with a thousand ties, who will be the joy of

her family for seventeen years, its white soul as Lamartine would say, but is destined to become its torment. When this man takes her from us he will begin by using her love for him as an axe to cut out, root and branch, from the living heart of this angel all the feelings which bound her to her family. Yesterday our daughter was all ours, as we were all hers; tomorrow she has changed into an enemy. Do we not see this tragedy enacted every day? Here a daughter-in-law is unspeakably rude to her father-in-law, who has sacrificed everything for his son. There a son-in-law turns his wife's mother from his door. I hear people asking if anything dramatic ever happens in society nowadays; but the drama of the son-in-law is appalling, to say nothing of our marriages which have become very sorry farces. I understand quite well what happened to the old vermicelli-maker. I believe I recollect that this Foriot—"

"Goriot, Madame."

"Yes, this Moriot was President of his Section during the Revolution; he was in the know about the notorious famine, and laid the foundation of his fortune at that time by selling flour for ten times as much as it cost him. He had as much flour as he wanted. My grandmother's land-steward sold him enormous quantities. This Noriot no doubt shared the loot, as persons of his kind always did, with the Committee for Public Welfare. I remember that the land-steward told my grandmother that she could remain in perfect safety at Grandvilliers, because her grain was an excellent certificate of civic merit. Well, this Loriot who sold corn to the cut-throats had only one passion, so they say: he adored his daughters. He gave the elder a roosting-place under the de Restaud roof, and grafted the other on the Baron de Nucingen: a rich banker who sets up for a Royalist. You can quite understand that so long as Buonaparte was Emperor the two sons-in-law did not much mind having the old '93 man in their houses: but when the Bourbons were restored it was a different story; the old fellow was in Monsieur de Restaud's way, and even more tiresomely in the banker's. The daughters, who were still perhaps fond of their father, wanted to save both the goat and the cabbage, to run with the hare and the hounds, to please both father and husband. They saw the Goriot when they had no other visitor, and invented pretexts for doing this which made it seem due only to affection. 'Papa, come at such-and-such a time. It will be nicer then because we shall be alone together!' and so forth. But I believe for my part, my dear, that real feeling has eyes and intelligence: the heart of our poor '93 must have bled. He saw that his daughters were ashamed of him; that if they loved their husbands he made trouble between them and his sons-in-law. He was bound to sacrifice himself then...."

Head of Balzac by Auguste Rodin. c. 1891. Terra cotta, height 9¼". The Metropolitan Museum of Art, New York. Rogers Fund, 1912

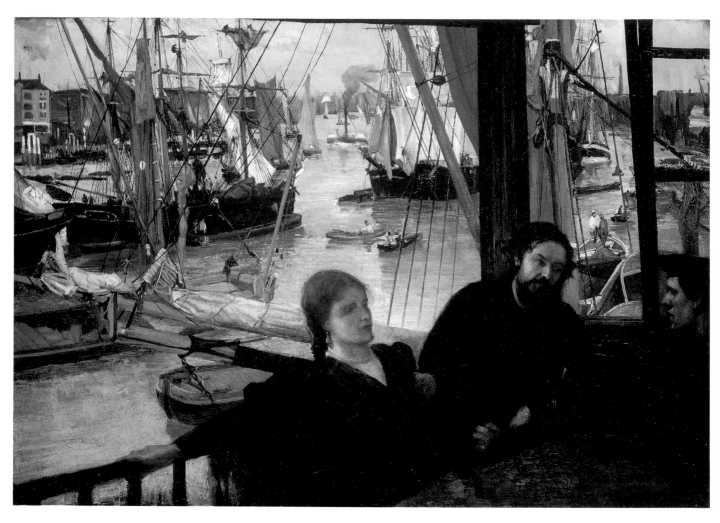

Wapping on Thames by James McNeill Whistler. 1860–64. Oil on canvas, 28½ × 40¼". The National Gallery of Art, Washington, D.C. John Hay Whitney Collection

What Was a Girl to Dombey and Son?
from *Dealings with the Firm of Dombey and Son*

Charles Dickens

"His father's name, Mrs. Dombey, and his grandfather's! I wish his grandfather were alive this day!" And again he said "Dom-bey and Son," in exactly the same tone as before.

Those three words conveyed the one idea of Mr. Dombey's life. The earth was made for Dombey and Son to trade in, and the sun and moon were made to give them light. Rivers and seas were formed to float their ships; rainbows gave them promise of fair weather; winds blew for or against their enterprises; stars and planets circled in their orbits, to preserve inviolate a system of which they were the centre. Common abbreviations took new meanings in his eyes, and had sole reference to them: A.D. had no concern with anno Domini, but stood for anno Dombei—and Son.

He had risen, as his father had before him, in the course of life and death, from Son to Dombey, and for nearly twenty years had been the sole representative of the firm. Of those years he had been married, ten—married, as some said, to a lady with no heart to give him; whose happiness was in the past, and who was content to bind her broken spirit to the dutiful and meek endurance of the present. Such idle talk was little likely to reach the ears of Mr. Dombey, whom it nearly concerned; and probably no one in the world would have received it with such utter incredulity as he, if it had reached him. Dombey and Son had often dealt in hides, but never in hearts. They left that fancy ware to boys and girls, and boarding-schools and books. Mr. Dombey would have reasoned: That a matrimonial alliance with himself *must*, in the nature of things, be gratifying and honourable to any woman of common sense. That the hope of giving birth to a new partner in such a house, could not fail to awaken a glorious and stirring ambition in the breast of the least ambitious of her sex. That Mrs. Dombey had entered on that social contract of matrimony: almost necessarily part of a genteel and wealthy station, even without reference to the perpetuation of family firms: with her eyes fully open to these advantages. That Mrs. Dombey had had daily practical knowledge of his position in society. That Mrs. Dombey had always sat at the head of his table, and done the honours of his house in a remarkably lady-like and becoming manner. That Mrs. Dombey must have been happy. That she couldn't help it.

Or, at all events, with one drawback. Yes. That he would have allowed. With only one; but that one certainly involving much. They had been married ten years, and until this present day on which Mr. Dombey sat jingling and jingling his heavy gold watch-chain in the great arm-chair by the side of the bed, had had no issue.

—To speak of; none worth mentioning. There had been a girl some six years before, and the child, who had stolen into the chamber unobserved, was now crouching timidly, in a corner whence she could see her mother's face. But what was a girl to Dombey and Son! In the capital of the House's name and dignity, such a child was merely a piece of base coin that couldn't be invested—a bad Boy—nothing more.

In Honor of David Anderson Brooks, My Father

July 30, 1883–November 21, 1959

Gwendolyn Brooks

A dryness is upon the house
My father loved and tended.
Beyond his firm and sculptured door
His light and lease have ended.

He walks the valleys, now—replies
To sun and wind forever.
No more the cramping chamber's chill,
No more the hindering fever.

Now out upon the wide clean air
My father's soul revives,
All innocent of self-interest
And the fear that strikes and strives.

He who was Goodness, Gentleness,
And Dignity is free,
Translates to public Love
Old private charity.

Men Exist for the Sake of One Another. Teach Them Then or Bear with Them (from the series *Great Ideas of Western Man*) by Jacob Lawrence. 1958. Oil on Masonite, 30¾ × 16¾". National Museum of American Art, Smithsonian Institution, Washington, D.C. Gift of the Container Corporation of America, 1984

Those Winter Sundays

Robert Hayden

Sundays too my father got up early
and put his clothes on in the blueblack cold,
then with cracked hands that ached
from labor in the weekday weather made
banked fires blaze. No one ever thanked him.

I'd wake and hear the cold splintering, breaking.
When the rooms were warm, he'd call,
and slowly I would rise and dress,
fearing the chronic angers of that house,

Speaking indifferently to him,
who had driven out the cold
and polished my good shoes as well.
What did I know, what did I know
of love's austere and lonely offices?

To Be Good She Must Be Patient
from *Washington Square*

Henry James

The idea of a struggle with her father, of setting up her will against his own, was heavy on her soul, and it kept her quiet, as a great physical weight keeps us motionless. It never entered into her mind to throw her lover off; but from the first she tried to assure herself that there would be a peaceful way out of their difficulty. The assurance was vague, for it contained no element of positive conviction that her father would change his mind. She only had an idea that if she should be very good, the situation would in some mysterious manner improve. To be good she must be patient, outwardly submissive, abstain from judging her father too harshly, and from committing any act of open defiance. He was perhaps right, after all, to think as he did; by which Catherine meant not in the least that his judgment of Morris's motives in seeking to marry her was perhaps a just one, but that it was probably natural and proper that conscientious parents should be suspicious and even unjust. There were probably people in the world as bad as her father supposed Morris to be, and if there were the slightest chance of Morris being one of these sinister persons, the Doctor was right in taking it into account. Of course he could not know what she knew—how the purest love and truth were seated in the young man's eyes; but Heaven, in its time, might appoint a way of bringing him to such knowledge. Catherine expected a good deal of Heaven, and referred to the skies the initiative, as the French say, in dealing with her dilemma. She could not imagine herself imparting any kind of knowledge to her father; there was something superior even in his injustice, and absolute in his mistakes. But she could at least be good, and if she were only good enough, Heaven would invent some way of reconciling all things—the dignity of her father's errors and the sweetness of her own confidence, the strict performance of her filial duties, and the enjoyment of Morris Townsend's affection.

Portrait of Miss Dora Wheeler by William Merritt Chase. 1883. Oil on canvas, 54½ × 65¼". The Cleveland Museum of Art, Ohio. Gift of Mrs. Boudinot Keith, in memory of Mr. and Mrs. J. H. Wade

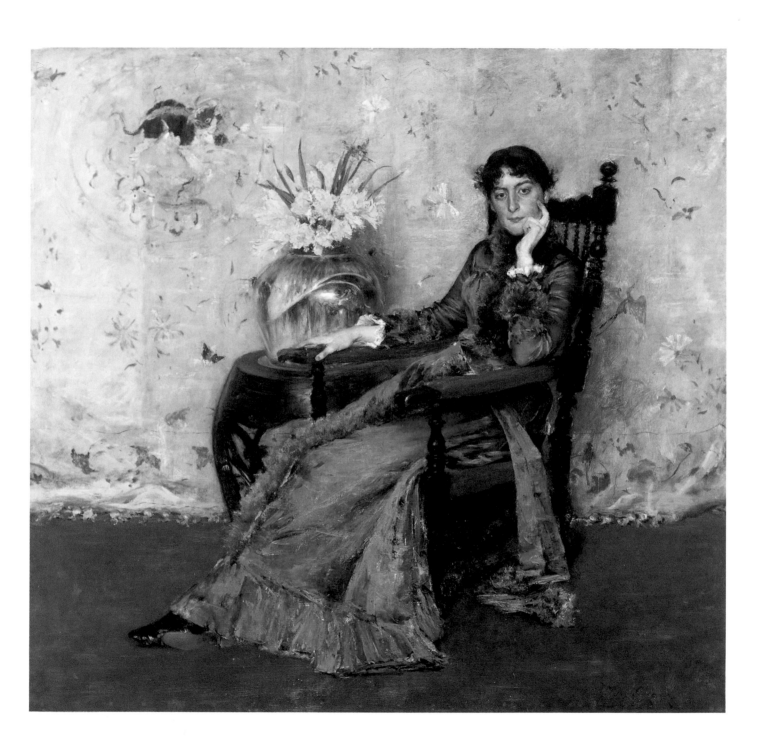

The Little Girl Who Eventually Became Me
from *A Backward Glance*

Edith Wharton

It was on a bright day of midwinter, in New York. The little girl who eventually became me, but as yet was neither me nor anybody else in particular, but merely a soft anonymous morsel of humanity—this little girl, who bore my name, was going for a walk with her father. The episode is literally the first thing I can remember about her, and therefore I date the birth of her identity from that day.

She had been put into her warmest coat, and into a new and very pretty bonnet, which she had surveyed in the glass with considerable satisfaction. The bonnet (I can see it today) was of white satin, patterned with a pink and green plaid in raised velvet. It was all drawn into close gathers, with a *bavolet* in the neck to keep out the cold, and thick ruffles of silky *blonde* lace under the brim in front. As the air was very cold a gossamer veil of the finest white Shetland wool was drawn about the bonnet and hung down over the wearer's round red cheeks like the white paper filigree over a Valentine; and her hands were encased in white woollen mittens.

One of them lay in the large safe hollow of her father's bare hand; her tall handsome father, who was so warm-blooded that in the coldest

weather he always went out without gloves, and whose head, with its ruddy complexion and intensely blue eyes, was so far aloft that when she walked beside him she was too near to see his face. It was always an event in the little girl's life to take a walk with her father, and more particularly so today, because she had on her new winter bonnet, which was so beautiful (and so becoming) that for the first time she woke to the importance of dress, and of herself as a subject for adornment—so that I may date from that hour the birth of the conscious and feminine *me* in the little girl's vague soul.

The little girl and her father walked up Fifth Avenue: the old Fifth Avenue with its double line of low brown-stone houses, of a desperate uniformity of style, broken only—and surprisingly—by two equally unexpected features: the fenced-in plot of ground where the old Miss Kennedys' cows were pastured, and the truncated Egyptian pyramid which so strangely served as a reservoir for New York's water supply. The Fifth Avenue of that day was a placid and uneventful thoroughfare, along which genteel landaus, broughams and victorias, and more countrified vehicles of the "carry-all" and "surrey" type, moved up and down at decent intervals and a decorous pace. On Sundays after church the fashionable of various denominations paraded there on foot, in gathered satin bonnets and tall hats; but at other times it presented long stretches of empty pavement, so that the little girl, advancing at her father's side was able to see at a considerable distance the approach of another pair of legs, not as long but considerably stockier than her father's. The little girl was so very little that she never got much higher than the knees in her survey of grown-up people, and would not have known, if her father had not told her, that the approaching legs belonged to his cousin Henry. The news was very interesting, because in attendance on Cousin Henry was a small person, no bigger than herself, who must obviously be Cousin Henry's little boy Daniel, and therefore somehow belong to the little girl. So when the tall legs and the stocky ones halted for a talk, which took place somewhere high up in the air, and the small Daniel and Edith found themselves face to face close to the pavement, the little girl peered with interest at the little boy through the white woollen mist over her face. The little boy, who was very round and rosy, looked back with equal interest; and suddenly he put out a chubby hand, lifted the little girl's veil, and boldly planted a kiss on her cheek. It was the first time—and the little girl found it very pleasant.

This is my earliest definite memory of anything happening to me; and it will be seen that I was wakened to conscious life by the two tremendous forces of love and vanity.

Photograph of Edith Wharton, Age Eight. 1870. Photograph. Courtesy Manuscript Department, Lilly Library, Indiana University, Bloomington, Indiana

Song to Be Sung by the Father of Six-Months-Old Female Children

Ogden Nash

My heart leaps up when I behold
A rainbow in the sky;
Contrariwise, my blood runs cold
When little boys go by.
For little boys as little boys,
No special hate I carry,
But now and then they grow to men,
And when they do, they marry.
No matter how they tarry,
Eventually they marry.
And, swine among the pearls,
They marry little girls.

Oh, somewhere, somewhere, an infant plays,
With parents who feed and clothe him.
Their lips are sticky with pride and praise,
But I have begun to loathe him.
Yes, I loathe with a loathing shameless
This child who to me is nameless.

This bachelor child in his carriage
Gives never a thought to marriage,
But a person can hardly say knife
Before he demands a wife.

I never see an infant (male),
A-sleeping in the sun,
Without I turn a trifle pale
And think, is *he* the one?
Oh, first he'll want to crop his curls,
And then he'll want a pony,
And then he'll think of pretty girls
And holy matrimony.
He'll put away his pony,
And sigh for matrimony.
A cat without a mouse
Is he without a spouse.

Oh somewhere he bubbles bubbles of milk,
And quietly sucks his thumbs.
His cheeks are roses painted on silk,
And his teeth are tucked in his gums.
But alas, the teeth will begin to grow,
And the bubbles will cease to bubble;
Given a score of years or so,
The roses will turn to stubble.
He'll sell a bond, or he'll write a book,
And his eyes will get that acquisitive look,
And raging and ravenous for the kill,
He'll boldly ask for the hand of Jill.

This infant whose middle
Is diapered still
Will want to marry
My daughter Jill.

Oh sweet be his slumber and moist his middle,
My dreams, I fear, are infanticiddle.
A fig for embryo Lohengrins!
I'll open all of his safety pins,
I'll pepper his powder, and salt his bottle,
And give him readings from Aristotle.
Sand for his spinach I'll gladly bring,
And tabasco sauce for his teething ring,
And an elegant, elegant alligator
To play with in the perambulator.
Then perhaps he'll struggle through fire
 and water
To marry somebody's
 else's daughter.

Child Wearing a Red Scarf by Edouard Vuillard.
c. 1891. Cardboard on wood, $11\frac{1}{2} \times 6\frac{7}{8}''$.
National Gallery of Art, Washington, D.C.
Ailsa Mellon Bruce Collection

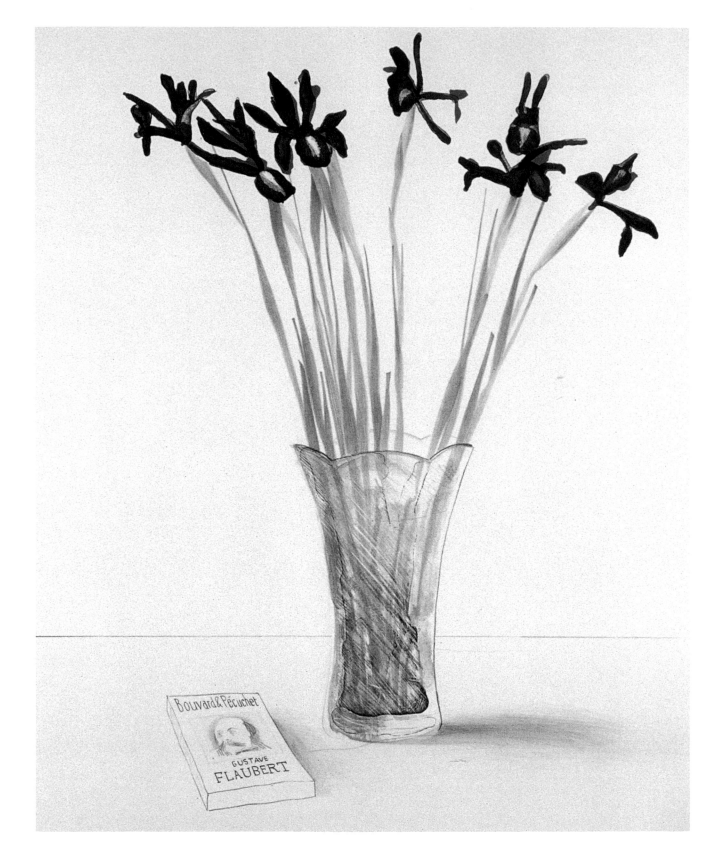

Bouvard & Pécuchet

GUSTAVE
FLAUBERT

Was It Their Fault They Were Born of a Convict Father?
from *Bouvard and Pécuchet*

Gustave Flaubert

A little farther on they stopped before a trellised enclosure, in which there were dog-kennels and a red-tiled cottage.

Victorine was on the doorstep. They could hear dogs barking. The gamekeeper's wife came out.

Knowing the reason of the mayor's visit, she called Victor.

Everything was prepared already, and their belongings in two handkerchiefs, fastened with pins.

"Good-bye," she said to them. "What a comfort to be rid of such vermin!"

Was it their fault that they were born of a convict father? On the contrary, they seemed quiet enough, and did not even worry where they were being taken.

Bouvard and Pécuchet watched them as they walked on in front.

Victorine was humming some indistinguishable words with her bundle on her arm, like a milliner carrying a band-box. From time to time she turned round, and Pécuchet, at the sight of her fair curls and pretty figure, regretted not having such a child of his own. Brought up in other surroundings, she would be charming later on. What a happiness to see her growing, to hear every day her bird-like chatter, to kiss her when he wanted; and a feeling of tenderness in his heart rose to his lips, making his eyes moist, oppressing him a little.

Victor, like a soldier, had slung his bundle over his shoulder. He whistled, threw stones at the crows in the furrows, and darted under the trees to cut switches. Foureau called him back; and Bouvard, holding him by the hand, enjoyed feeling the strong, vigorous fingers of the lad within his own. The poor little devil asked for nothing but to be allowed to grow freely, like a flower in the open; and he would wither up between walls, with lessons, punishments, a heap of idiocies! Bouvard was seized with an impulse of pity, an indignation against fate, one of those rages in which one wants to down the Government.

"Frisk about!" he said. "Enjoy yourself! Play while you can!"

The youngster ran off.

His sister and he were to sleep at the inn, and at daybreak the messenger from Falaise would take Victor and set him down at the reformatory of Beaubourg; a sister from the orphanage at Grand-Camp would come to fetch Victorine.

Foureau, after giving these details, plunged back into his own reflections. But Bouvard wished to know how much the maintenance of these two children would cost.

Still Life with Book by David Hockney. 1973. Lithograph, 27 × 22". Courtesy Tradhart, Ltd., England. © David Hockney

I Am Not Your Son and I Am Not Japanese and I Am Not American
from *No-No Boy*

John Okada

No, he said to himself as he watched her part the curtains and start into the store. There was a time when I was your son. There was a time that I no longer remember when you used to smile a mother's smile and tell me stories about gallant and fierce warriors who protected their lords with blades of shining steel and about the old woman who found a peach in the stream and took it home, and, when her husband split it in half, a husky little boy tumbled out to fill their hearts with boundless joy. I was that lad in the peach and you were the old woman and we were Japanese with Japanese feelings and Japanese pride and Japanese thoughts because it was all right then to be Japanese and feel and think all the things that Japanese do even if we lived in America. Then there came a time when I was only half Japanese because one is not born in America and raised in America and taught in America and one does not speak and swear and drink and smoke and play and fight and see and hear in America among Americans in American streets and houses without becoming American and loving it. But I did not love enough for you were still half my mother and I was thereby still half Japanese and when the war came and they told me to fight for America, I was not strong enough to fight you and I was not strong enough to fight the bitterness which made the half of me which was bigger than the half of me which was America and really the whole of me that I could not see or feel. Now that I know the truth when it is late and the half of me and the half that remains is enough to know why it was that I could not fight for America and did not strip me of my birthright. But it is not enough to be only half an American and know that it is an empty half. I am not your son and I am not Japanese and I am not American. I can go someplace and tell people that I've got an inverted stomach and that I am an American, true and blue and Hail Columbia, but the army wouldn't have me because of the stomach. That's easy and I would do it, only I've got to convince myself first and that I cannot do. I wish with all my heart that I were Japanese or that I were American. I am neither and I blame you and I blame myself and I blame the world which is made up of many countries which fight with each other and kill and hate and destroy again and again and again. It is so easy and simple that I cannot understand it at all. And the reason I do not understand it is because I do not understand you who were the half of me that is no more and because I do not understand what it was about the half of me which was American and the half which might have become the whole of me if I had said yes I will go and fight in your army because that is what I believe and want and cherish and love.

Haniwa Warrior Figure by an unknown Japanese artist. Haniwa, Tumuli period, 200–552 A.D. Polychrome pottery, height 53½", width 16½", diameter 10¾". Seattle Art Museum. Eugene Fuller Memorial Collection

My Son, My Executioner

Donald Hall

My son, my executioner,
 I take you in my arms,
Quiet and small and just astir,
 And whom my body warms.

Sweet death, small son, our instrument
 Of immortality,
Your cries and hungers document
 Our bodily decay.

We twenty-five and twenty-two,
 Who seemed to live forever,
Observe enduring life in you
 And start to die together.

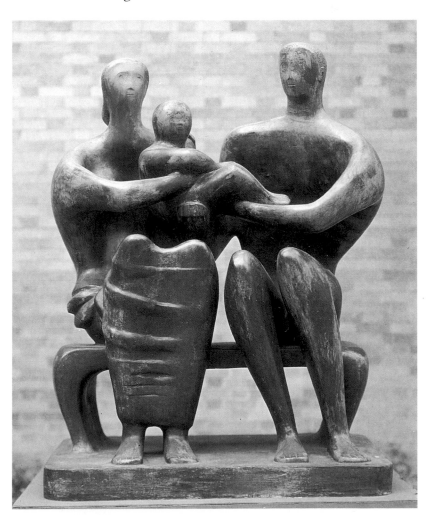

Family Group by Henry Moore. 1948–49.
Bronze (cast 1950), 59¼ × 46½ × 29⅞",
including base. The Museum of Modern Art,
New York. A. Conger Goodyear Fund

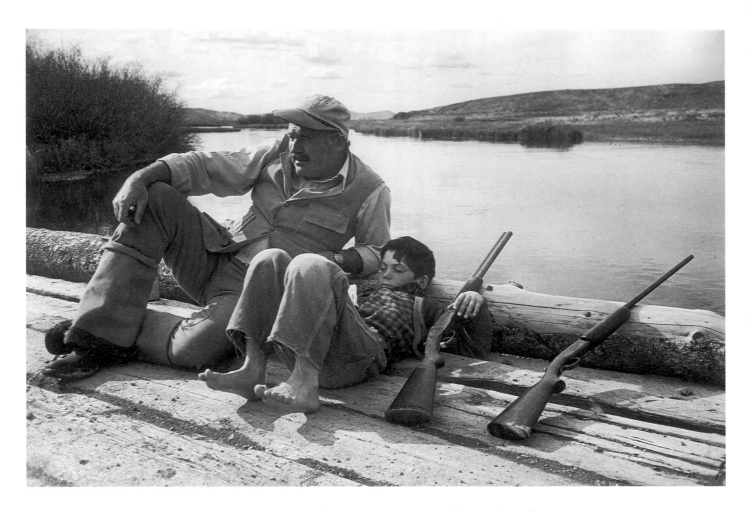

Ernest Hemingway and His Son Gregory, Sun Valley, October 1941.
Photograph by Robert Capa

Children All O.K.

from a letter by Ernest Hemingway to Charles Scribner

To CHARLES SCRIBNER, Sun Valley, *c.* 20 November 1941

We are going to drive south through Utah to Arizona and then through Texas to the Gulf. Next address for mail until December First is care Mrs. Mathew Baird—Ruby Star Route—Tucson, Arizona. Don't want to come to N.Y. this fall. May have to come after the first of the year on some tax business. I wish you wouldn't pay me any more money the rest of this year if you can help it. Can't you pay it next year? Will have no money next year and am starting work on a book in January.

Will wire Max where to send mail after the Baird address. Hope you are well and have had a good fall. We had fine shooting all fall and now with it around zero there is wonderful duck and goose shooting. Going out now to a pass between two low hills, lowest on a range of mountains along Silver Creek [at Picabo, Idaho] where the flight comes through in bunches, comeing so fast you would think they were going to knock you over. All big northern mallards and pintails.

Children all o.k. Martha is fine and very beautiful and happy. She is anxious to get back to Cuba.

Best to you always,
Ernest

His Father Came Back to Him the Fall of the Year
from *"Fathers and Sons"*

Ernest Hemingway

His father came back to him the fall of the year, or in the early spring when there had been jacksnipe on the prairie, or when he saw shocks of corn, or when he saw a lake, or if he ever saw a horse and buggy, or when he saw, or heard, wild geese, or in a duck blind; remembering the time an eagle dropped through the whirling snow to strike a canvas-covered decoy, rising, his wings beating, the talons caught in the canvas. His father was with him, suddenly, in deserted orchards and in new-plowed fields, in thickets, on small hills, or when going through dead grass, whenever splitting wood or hauling water, by grist mills, cider mills and dams and always with open fires. The towns he lived in were not towns his father knew. After he was fifteen he had shared nothing with him.

The Rainbow

William Wordsworth

My heart leaps up when I behold
A rainbow in the sky:
So was it when my life began;
So is it now I am a man;
So be it when I shall grow old,
　　　　Or let me die!
The Child is father of the Man;
And I could wish my days to be
Bound each to each by natural piety.

I Shall Soon Be a Father Again

from a letter by Paul Gauguin to Georges de Monfried, March 31, 1893, Tahiti

I shall soon be a father again in Oceanica. Good Heavens, I seem to sow everywhere! But here it does no harm, for children are welcome and are spoken for in advance by all the relatives. It's a struggle as to who should be the mother and father nurse. For you know that in Tahiti a child is the most beautiful present one can give. So I do not worry as to its fate.

Portrait of the Artist by Paul Gauguin. c. 1893–94. Oil on canvas, 18⅛ × 15″. Musée d'Orsay, Paris

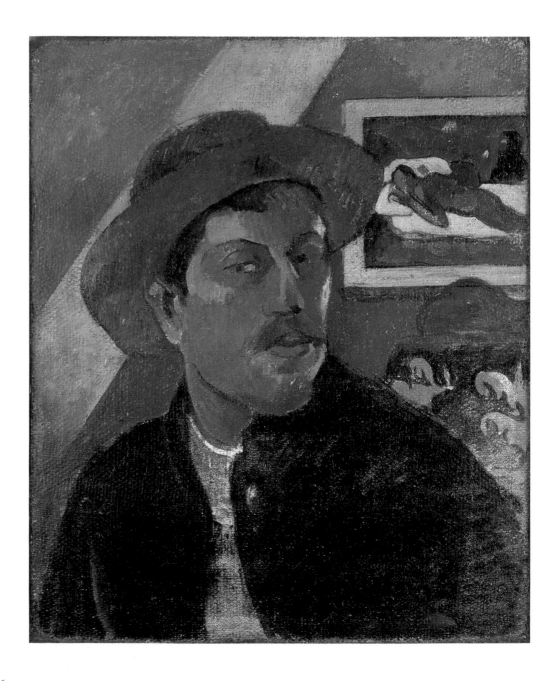

I Show Them Gauguin's Tahitian Pictures…

from an interview with Robert Coles

With some children, I not only asked them to draw and paint. I would take some art books and we would sit and look at pictures—a Renoir painting, some works by van Gogh, and especially Käthe Kollwitz's drawings and lithographs. I'd show them to the children, and they'd construct their stories, and I would learn more both about the children and about what these works of art can say.

Do you use works by these artists in the Boston classrooms?

Yes. I show them Gauguin's Tahitian pictures. There's one painting in the Boston Museum of Fine Arts that has, written at the top in French, "Where Do We Come From? What Are We? Where Are We Going?" I ask the kids what they think about these questions. I show them a map, and I help them locate where Tahiti is. I show them where Australia is, and Vietnam. A lot of kids don't know where Vietnam is on a map, but they know that they lost an uncle there, or a father or a grandfather. I give them, in a sense, a geography lesson of the Pacific. And I show them where France is, and tell them something about Gauguin's life. The picture and its questions get them going on their thoughts about life and where they'd like to live and why they'd want to move from one part of the world to the next. They draw from those children the rarest phenomena in the fourth grade—namely silence and speculation and reflection.

Dr. Robert Coles with Children. Photograph by Alex Harris. c. 1992

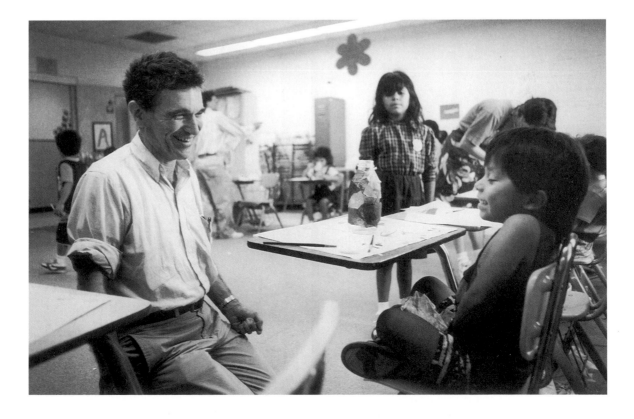

Progress Report to a Dead Father

Judith Ortiz Cofer

"Keep it simple, keep it short,"
you'd say to me, "Get to the point,"
when the hoard of words I had stored for you
like bits of bright tinsel in a squirrel's nest
distracted you from the simple "I love you"
that stayed at tongue-tip.

Father, I am no more succinct now than when
you were alive; the years have added reams
to my forever manuscript.
Lists rile me now in your stead,
labeled "things to do today" and
"do not forget," lists of things
I will never do, lists that I write
to remind me that I can never forget.

I can still hear you say,
"A place for everything and
everything in its place."
But chaos is my roommate now, Father,
and he entertains often.

Simplicity is for the strong-hearted,
you proved that with your brief
but thorough life. Your days were stacked
like clean shirts in a drawer.
Death was the point you drove home
the day your car met the wall,
your forehead split in two, not in your familiar frown,
but forever—a clean break.
"It was quick," the doctor said, "He didn't feel a thing."

It was not your fault that love could not be
so easily put in its right place
where I could find it when I needed it,
as the rest of your things, Father.

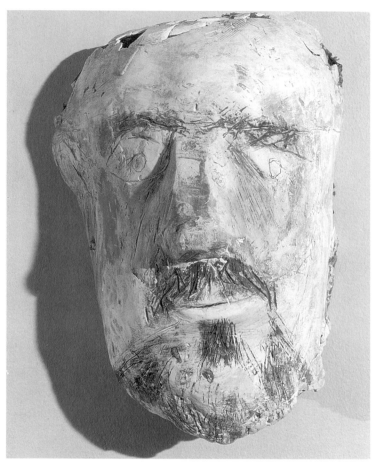

Untitled by Manuel Neri. Date unknown. Plaster
with gouache and graphite, $14\frac{5}{8} \times 10\frac{3}{4} \times 6\frac{1}{2}''$.
San Francisco Museum of Modern Art, California.
Gift of Robert B. Howard

In the Tree House at Night

James Dickey

And now the green household is dark.
The half-moon completely is shining
On the earth-lighted tops of the trees.
To be dead, a house must be still.
The floor and the walls wave me slowly;
I am deep in them over my head.
The needles and pine cones about me

Are full of small birds at their roundest,
Their fists without mercy gripping
Hard down through the tree to the roots
To sing back at light when they feel it.
We lie here like angels in bodies,
My brothers and I, one dead,
The other asleep from much living,

In mid-air huddled beside me.
Dark climbed to us here as we climbed
Up the nails I have hammered all day
Through the sprained, comic rungs of the ladder
Of broom handles, crate slats, and laths
Foot by foot up the trunk to the branches
Where we came out at last over lakes

Of leaves, of fields disencumbered of earth
That move with the moves of the spirit.
Each nail that sustains us I set here;
Each nail in the house is now steadied
By my dead brother's huge, freckled hand.
Through the years, he has pointed his hammer
Up into these limbs, and told us

That we must ascend, and all lie here.
Step after step he has brought me,
Embracing the trunk as his body,
Shaking its limbs with my heartbeat,
Till the pine cones danced without wind
And fell from the branches like apples.
in the arm-slender forks of our dwelling

I breathe my live brother's light hair.
The blanket around us becomes
As solid as stone, and it sways.
With all my heart, I close
The blue, timeless eye of my mind.
Wind springs, as my dead brother smiles
And touches the tree at the root;

A shudder of joy runs up
The trunk; the needles tingle;
One bird uncontrollably cries.
The wind changes round, and I stir
Within another's life. Whose life?
Who is dead? Whose presence is living?
When may I fall strangely to earth,

Who am nailed to this branch by a spirit?
Can two bodies make up a third?
To sing, must I feel the world's light?
My green, graceful bones fill the air
With sleeping birds. Alone, alone
And with them I move gently.
I move at the heart of the world.

The Treehouse

James Emanuel

To every man
His treehouse,
A green splice in the humping years,
Spartan with narrow cot
And prickly door.

To every man
His twilight flash
Of luminous recall
 of tiptoe years
 in leaf-stung flight;
 of days of squirm and bite
 that waved antennas through the grass;
 of nights
 when every moving thing
 was girlshaped,
 expectantly turning.

To every man
His house below
And his house above—
With perilous stairs
Between.

I'm Sorry for Old Adam

from a folk song

He never had no childhood,
Playin' round the cabin door,
And he never had no daddy
For to tell him all he know.

The Tree of Houses by Paul Klee. 1918. Watercolor and ink on chalk-primed gauze on papers, mounted on painted board, 9⅝ × 7⅞". Norton Simon Museum, Pasadena, California. The Blue Four Galka Scheyer Collection

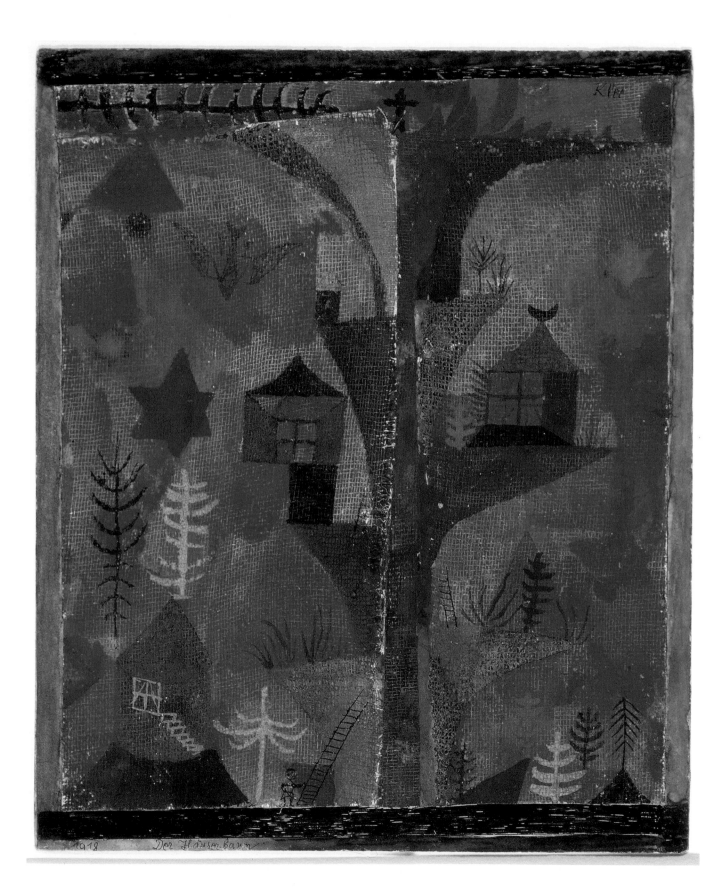

The Papa and Mama Dance

Anne Sexton

Taking into consideration all your loveliness
why can't you burn our bootsoles and your
draft card? How can you sit there saying yes
to war? You'll be a pauper when you die, sore
boy. Dead, while I still live at our address.
Oh my brother, why do you keep making plans
when I am at seizures of hearts and hands?
Come dance the dance, the Papa-Mama dance;
bring costumes from the suitcase pasted *Ile de France*,
the S.S. *Gripsholm*. Papa's London Harness case
he took abroad and kept in our attic laced
with old leather straps for storage and his
scholar's robes, black licorice—that metamorphosis
with its crimson hood. Remember we played costume—
bride black and black, black, black the groom?

Five A.M. by Jennifer
Bartlett. 1991–92. Oil on
canvas, 84 × 84″. The
Metropolitan Museum of
Art, New York. Joseph H.
Hazen Foundation Purchase
Fund, in honor of Cynthia
Hazen Polsky, 1992

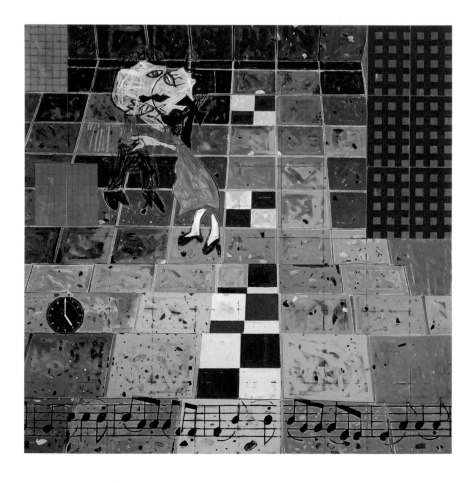

Taking into consideration all your loveliness,
the mad hours where once we danced on the sofa
screaming Papa, Papa, Papa, me in my dress,
my nun's habit and you black as a hammer, a bourgeois
priest who kept leaping and leaping and leaping,
Oh brother, Mr. Gunman, why were you weeping,
inventing curses for your sister's pink, pink ear?
Taking aim and then, as usual, being sincere,
saying something dangerous, something egg-spotted
like *I love you*, ignoring the room where we danced,
ignoring the gin that could get us honestly potted,
and crying Mama, Mama, Mama, that old romance:
I tell you the dances we had were really enough,
your hands on my breast and all that sort of stuff.

Remember the yellow leaves that October day
when we married the tree hut and I didn't go away?
Now I sit here burying the attic and all of your
loveliness. If I jump on the sofa you just sit
in the corner and then you just bang on the door.
YOU WON'T REMEMBER! Yes, Mr. Gunman, that's it!
Isn't the attic familiar? Doesn't the season
trample your mind? War, you say. War, you reason.
Please Mr. Gunman, dance one more, commenting
on costumes, holding them to your breast, lamenting
our black love and putting on that Papa dress.
Papa and Mama did so. Can we do less?

The Aging Lovers

John Ciardi

Why would they want one another,
those two old crocks of habit
up heavy from the stale bed?

Because we are not visible where we dance,
though a word none hears can call us
to the persuasion of kindness, and there sing.

The Writer

Richard Wilbur

In her room at the prow of the house
Where light breaks, and the windows are tossed with linden,
My daughter is writing a story.

I pause in the stairwell, hearing
From her shut door a commotion of typewriter-keys
Like a chain hauled over a gunwale.

Young as she is, the stuff
Of her life is a great cargo, and some of it heavy:
I wish her a lucky passage.

But now it is she who pauses,
As if to reject my thought and its easy figure.
A stillness greatens, in which

The whole house seems to be thinking,
And then she is at it again with a bunched clamor
Of strokes, and again is silent.

I remember the dazed starling
Which was trapped in that very room, two years ago;
How we stole in, lifted a sash

And retreated, not to affright it;
And how for a helpless hour, through the crack of the door,
We watched the sleek, wild, dark

And iridescent creature
Batter against the brilliance, drop like a glove
To the hard floor, or the desk-top,

Wind from the Sea by Andrew Wyeth. 1947. Tempera, 18½ × 27½". Mead Art Museum, Amherst College, Massachusetts. Gift of Charles and Janet Morgan

And wait then, humped and bloody,
For the wits to try it again; and how our spirits
Rose when, suddenly sure,

It lifted off from a chair-back,
Beating a smooth course for the right window
And clearing the sill of the world.

It is always a matter, my darling,
Of life or death, as I had forgotten. I wish
What I wished you before, but harder.

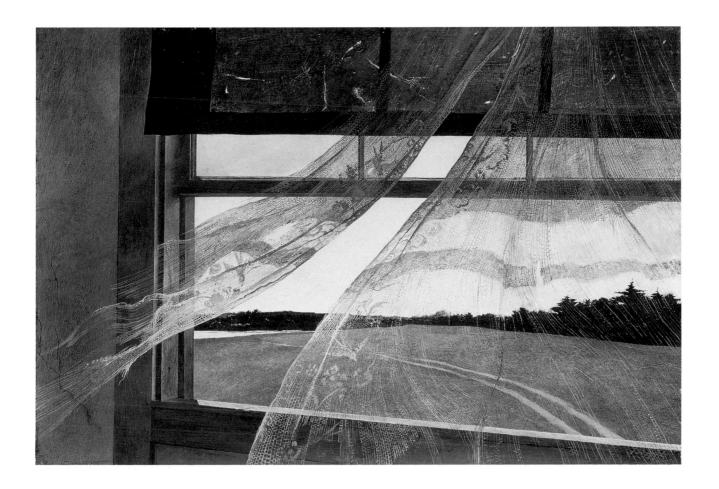

Cottage Street, 1953

Richard Wilbur

Framed in her phoenix fire-screen, Edna Ward
Bends to the tray of Canton, pouring tea
For frightened Mrs. Plath; then, turning toward
The pale, slumped daughter, and my wife, and me,

Asks if we would prefer it weak or strong.
Will we have milk or lemon, she enquires?
The visit seems already strained and long.
Each in his turn, we tell her our desires.

It is my office to exemplify
The published poet in his happiness,
Thus cheering Sylvia, who has wished to die;
But half-ashamed, and impotent to bless,

I am a stupid life-guard who has found,
Swept to his shallows by the tide, a girl
Who, far from shore, has been immensely drowned,
And stares through water now with eyes of pearl.

How large is her refusal; and how slight
The genteel chat whereby we recommend
Life, of a summer afternoon, despite
The brewing dusk which hints that it may end.

And Edna Ward shall die in fifteen years,
After her eight-and-eighty summers of
Such grace and courage as permit no tears,
The thin hand reaching out, the last word *love,*

Outliving Sylvia who, condemned to live,
Shall study for a decade, as she must,
To state at last her brilliant negative
In poems free and helpless and unjust.

Every Girl's Dream by Ralph Goings. 1962. Oil on
canvas, 49½ × 45 ". San Francisco Museum of Modern
Art, California. Gift of Bill Bass, Chicago

Daddy

Sylvia Plath

You do not do, you do not do
Any more, black shoe
In which I have lived like a foot
For thirty years, poor and white,
Barely daring to breathe or Achoo.

Daddy, I have had to kill you.
You died before I had time—
Marble-heavy, a bag full of God,
Ghastly statue with one grey toe
Big as a Frisco seal

And a head in the freakish Atlantic
Where it pours bean green over blue
In the waters off beautiful Nauset.
I used to pray to recover you.
Ach, du.

In the German tongue, in the Polish town
Scraped flat by the roller
Of wars, wars, wars.
But the name of the town is common.
My Polack friend

Says there are a dozen or two.
So I never could tell where you
Put your foot, your root,
I never could talk to you.
The tongue stuck in my jaw.

It stuck in a barb wire snare.
Ich, ich, ich, ich,
I could hardly speak.
I thought every German was you.
And the language obscene

An engine, an engine
Chuffing me off like a Jew.
A Jew to Dachau, Auschwitz, Belsen.
I began to talk like a Jew.
I think I may well be a Jew.

The snows of the Tyrol, the clear beer of Vienna
Are not very pure or true.
With my gypsy ancestress and my weird luck
And my Taroc pack and my Taroc pack
I may be a bit of a Jew.

I have always been scared of *you*,
With your Luftwaffe, your gobbledygoo.
And your neat moustache
And your Aryan eye, bright blue.
Panzer-man, panzer-man, O You—

Not God but a swastika
So black no sky could squeak through.
Every woman adores a Fascist,
The boot in the face, the brute
Brute heart of a brute like you.

You stand at the blackboard, daddy,
In the picture I have of you,
A cleft in your chin instead of your foot
But no less a devil for that, no not
Any less the black man who

Bit my pretty red heart in two.
I was ten when they buried you.
At twenty I tried to die
And get back, back, back to you.
I thought even the bones would do.

But they pulled me out of the sack,
And they stuck me together with glue.
And then I knew what to do.
I made a model of you,
A man in black with a Meinkampf look

And a love of the rack and the screw.
And I said I do, I do.
So daddy, I'm finally through.
The black telephone's off at the root,
The voices just can't worm through.

If I've killed one man, I've killed two—
The vampire who said he was you
And drank my blood for a year,
Seven years, if you want to know.
Daddy, you can lie back now.

There's a stake in your fat black heart
And the villagers never liked you.
They are dancing and stamping on you.
They always *knew* it was you.
Daddy, daddy, you bastard, I'm through.

The Praying Jew (Rabbi of Vitebsk) by Marc Chagall. 1914. Oil on canvas, 18⅛ × 13¾". The Art Institute of Chicago. The Joseph Winterbotham Collection, 1937

Did Your Father Ever Beat You?
from *"The Law"*

Hugh Nissenson

It was early spring, and warm, with a weak sun, gray clouds, cumuli, with a flat base and rounded outlines, piled up like mountains in the western sky. I remember that distinctly—cumuli. It was a matter of life and death, learning to tell one type of cloud from another—the promise of a little rain. There was never enough water. Just two concrete basins to supply the entire camp. We were slowly dying of thirst in addition to everything else. I remember thinking that if the rain does come I shall try and remain outside the barracks as long as I can after roll call, with my mouth open. Crazy thoughts. What was it? Chickens, young Truthähne—turkeys drown that way in the rain, too stupid to close their mouths. Insane, disconnected thoughts while, according to regulation, I stood rigidly at attention, with my chin in, and chest out, my thumbs along the crease in my striped prison pants, as Heinz drones on and on.

"Honor thy father and thy mother.... Thou shalt not murder...." On and on to the end, and then, with what I can only describe as a shy expression on his face, the explanation:

"We live in Saxony," he tells me. "Absolutely charming, Levy. Do you know East Prussia? Ah, the orchard and the flower beds—roses, red and white roses, growing in front of the church. My father's church. A pastor, Levy, and his father before him and before that. Three generations of pastors. When I was young, I thought I would go into the Church myself. I have the religious temperament."

"Yes, sir. Jawohl, Herr Hauptsturmführer."

"Does that astonish you?"

"Not at all, Mein Herr."

"It does, of course.... Sundays.... Ah, a day like today. The church bells echoing in the valley and the peasants in their black suits and creaking shoes shuffling between those rose beds to listen to Papa thunder at them from the pulpit, slamming down his fist. 'Love, my friends! It is written that we are to love our neighbors as ourselves.' The fist again. 'Love!' he shouts, and I would begin to tremble, literally begin to shake. Why, Levy? I often asked myself. You ought to know. Jews are great psychologists. Freud..."

"I don't know, Herr Hauptsturmführer."

"A pity.... He preached love and all I could see from that front pew was that great fist—the blond hair on the backs of the fingers, the knuckles clenched, white. That huge fist protruding from the black cuff like the hand of God from a thunder cloud." That was his image, I swear it. So help me, a literary mind. "Die grosse Faust ist aus der schwarzen Manschette heraus gestreckt wie Gotteshand aus einer Sturmwolke. Yet, to be honest," Heinz went on, "he never struck me. Not once in my whole life, and I was never what you could call a good child, Levy. Secret vices, a rebellious spirit that had to be broken. And obedience was doubly difficult for the likes of me, but as I've said, whenever I misbehaved, he never once laid a hand on me.... Love.... He spoke about love and was silent. Talk about psychology! That silence for days on end; all he had to do was say nothing and I would lie in my bed at night, trembling. Can you explain that, Levy? I would lie awake praying that he would beat me instead, smash me with that fist, flay my back with his belt rather than that love, that silent displeasure. To please him, I learned whole passages of the Bible by heart; your Bible, Levy."

He tapped his whip against the top of his boots.

"Tell me, Levy...."

"Yes, sir."

"I know the Jews; a gentle people. Tell me honestly. Did your father ever beat you?"

"No, sir."

"Not once?"

"Never, sir."

"A gentle people, as I've said, but lax in your education, wouldn't you say?"

"Yes, sir."

"Well, then we must remedy that."

Willi relit his cigar, took a puff, and left it in the ashtray. I stood at attention all afternoon. He whipped me across the back until I learned the Ten Commandments by heart, and could repeat them word for word at his command: "I am the Lord thy God, which have brought thee out of the land of Egypt, out of the house of bondage." "Thou shalt not!" "Thou shalt not!" "Thou shalt not!"

Son and Father

Cecil Day-Lewis

By the glim of a midwinterish early morning
Following habit's track over comatose fields,
A path of bleak reminder, I go to receive
The sacraments from my father, thirty years back.

Afterwards, walking home, unannealed, implacable,
I knew in the bones of my age this numb, flayed air,
These frozen grassblades rasping the foot, those hoar-drops
Which hung from a branch all day like unredeemed pledges.

Oh, black frost of my youth, recalcitrant time
When love's seed was benighted and gave no ear
To others' need, you were seasonable, you were
In nature: but were you as well my nature's blight?

Die Ordnung der Engel (Order of Angels)
by Anselm Kiefer. 1983–84. Oil,
emulsion, shellac, straw, and lead on
canvas, 129⅞ × 218½". The Art
Institute of Chicago. Restricted gift of
the Nathan Manilow Foundation, and
Lewis and Susan Manilow; Samuel A.
Marx Fund, 1985

That was thirty years back. The father is dead whose image
And superscription upon me I had to efface
Or myself be erased. Did I thus, denying him, grow
Quite dead to the Father's grace, the Son's redemption?

Ungenerous to him no more, but unregenerate,
Still on a frozen earth I stumble after
Each glimmer of God, although it lights up my lack,
And lift my maimed creations to beg rebirth.

Elegy to the Unborn City

Abdul Wahab Al-Bayati

translated from Arabic by Bassam K. Frangieh

Buzzing with people and flies,
I was born in it, and
On its walls I learned exile and wandering,
Love and death and the isolation of poverty
In its underworld and at its gates.
In it my father taught me to navigate and to read:
The rivers, the fires, the clouds, and the mirage,
He taught me to know sadness, rebellion, and perseverance,
To sail, and to circle the houses of the saints of god,
Searching for the light and the warmth of a future spring
Which still lives at the bottom of the earth
And in the sea shells,
Awaiting the prophecy of a fortune teller.
In it he taught me to wait for the night and the day
And to search for a hidden, enchanted city
On the map of the world
Similar to my city
In the color of its eyes and in its sad laugh,
But not wearing
The tatters of the wandering clown,
Nor does its summer buzz with people and flies.

A Tunisian boy's ideal vision of his town. Illustration from *Their Eyes Meeting the World*. © 1992 by Robert Coles. Reprinted by permission of Houghton Mifflin Co. All rights reserved

Under the Sign of the Palm

Jean Nordhaus

Poised at my window
under the sign of the palm
under the eyes of a goddess
disguised as a virgin,
I take your hand and tell you
all the lies I know:

> You will inherit a fortune.
> You will have seven children,
> all boys. Someone you loved
> will return. You will make
> a long journey soon over water.

I do not tell you that all journeys
are over water, that the white-eyed
horse of fear will always haunt you
and the child's obsessive dying.
I see illness, the house in flames,
the shadowed wall, the swift cascade
of seasons, the web of your life
growing aimless and vague at the edges.
I see you falling

out of the palm that holds you safe
into the curving dark, I see
the long swoon backward into space
and the slow swim up through darkness
over the lip of the world
into light.

Your body is waiting, and you climb into it.
You pull on the blue chemise and the cotton skirt
figured with animals walking.
Dolphins lift their perfect torsos
out of the water, calling after you.
Elephants circle your thighs.
You fasten the raspberry glass to your ears
and move inland

toward this meeting under the sign
of the palm, this room
where I wait with my bracelet of lies.

Phaeton

Sandra M. Gilbert

For years you've watched them from behind white
> curtains,
enormous horses with iron hooves, their breath
scrawled across the sky like jet trails, flanks

huge as Adirondacks, manes the tangled brush
where the three-year-old child is lost
and the rabbit screams in the hunter's snare.

Their hides heave and sizzle, their nostrils
are holes from which oblivion pours in wreaths,
their teeth high stalactites of dry ice.

A spindly kid, blond, uncertain, you hang on
to your mother's middle finger where
the emerald ring winks like spring,

don't talk much, play mostly with girls:
other boys ignore you; your father's
been away for years, fighting overseas.

They're your father's horses, your mother says,
sultry evenings when the great hooves
tattoo the stone stable floor.

*Don't be frightened, they're
your father's horses.* Sometimes
you sneak to the glowing doorway

and stare, stare.
> Their whinny
pierces you like the shout of light

you saw once when the dawn sun
leaped out of the Atlantic.
You clench small fists.

 You want to
whip those haunches till blood
spurts like a hot lather, a halo;

you want to rip out those stiffened manes
the way a gardener
uproots furious platoons of goldenrod.

Horse and Rider by Mary Frank. 1982. Ceramic,
24 × 43 × 31½″. Everson Museum of Art, New
York. Purchase with funds from the J. Stanley
Coyne Foundation

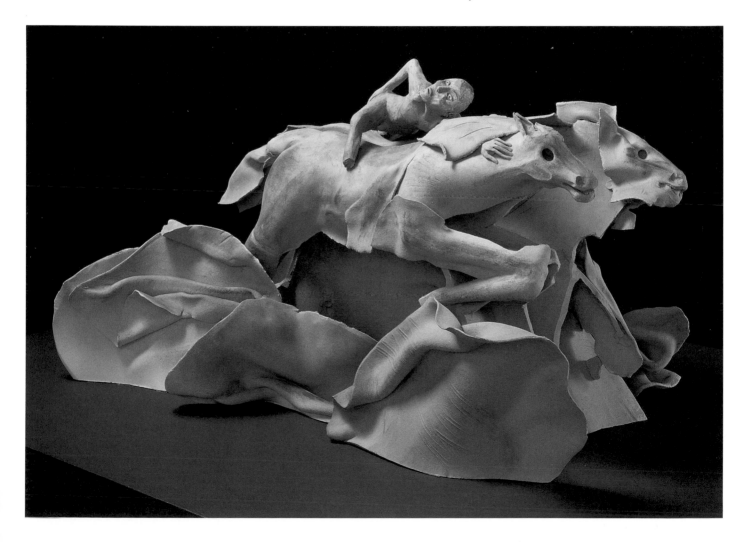

The Wings of Youth
from *A Portrait of the Artist as a Young Man*

James Joyce

16 *April:* Away! Away!

The spell of arms and voices: the white arms of roads, their promise of close embraces and the black arms of tall ships that stand against the moon, their tale of distant nations. They are held out to say: We are alone. Come. And the voices say with them: We are your kinsmen. And the air is thick with their company as they call to me, their kinsman, making ready to go, shaking the wings of their exultant and terrible youth.

26 *April:* Mother is putting my new secondhand clothes in order. She prays now, she says, that I may learn in my own life and away from home and friends what the heart is and what it feels. Amen. So be it. Welcome, O life! I go to encounter for the millionth time the reality of experience and to forge in the smithy of my soul the uncreated conscience of my race.

27 *April:* Old father, old artificer, stand me now and ever in good stead.

Self-Portrait by Hilaire Germain Edgar Degas. c. 1854. Oil on paper, mounted on canvas, 16 × 13½". The Metropolitan Museum of Art, New York. Bequest of Stephen C. Clark, 1960

A Prayer to the Mountain

John Ciardi

Of the electric guitar as a percussion instrument
and of my son who wails twelve hours an animal day
in the stoned cellar of my house I sing, oh pot-head baby
from the rock rolled Nine Sisters classic crag group
hit album featuring The Body Counts in "I'm Blowing it Now"
from "Don't Have to Have a Reason till I Stop."

And pray to you, Apollo, first of indulgent fathers
to weep a thunderstruck son down from the high hots
on more horsepower than God could let run
and not fear. And also as the angel who backed
The Nine Sisters to all-time superstardom
on warehouses full of gold millionth albums
and a tax structure that could have saved England.

As you watched Daedalus once watch his boy down
from a high beyond warning, watched and remembered Phaeton
trailing a sky-scar, watched the man watch,
his eyes wind-watered but holding himself to flight-trim,
balancing slow cold turns down the hot shaft
the boy plunged, and hover at last too late
over the placeless water that had taken and closed...

Grant us, father, not a denial of energy,
its space-trip spree above environment,
but a rest of purposes after the seized seizure,
the silence after the plunge without the plunge,
a fulfillment not necessarily final,
an excursion not from but to one another.
—I ask as a son in thy son's name for my son.

Musée des Beaux Arts

W. H. Auden

About suffering they were never wrong,
The Old Masters: how well they understood
Its human position; how it takes place
While someone else is eating or opening a window or just
 walking dully along;
How, when the aged are reverently, passionately waiting
For the miraculous birth, there always must be
Children who did not specially want it to happen, skating
On a pond at the edge of the wood:
They never forgot
That even the dreadful martyrdom must run its course
Anyhow in a corner, some untidy spot
Where the dogs go on with their doggy
 life and the torturer's horse
Scratches its innocent behind on a tree.

In Brueghel's *Icarus*, for instance: how everything turns away
Quite leisurely from the disaster; the ploughman may
Have heard the splash, the forsaken cry,
But for him it was not an important failure; the sun shone
As it had to on the white legs disappearing into the green
Water; and the expensive delicate ship that must have seen
Something amazing, a boy falling out of the sky,
Had somewhere to get to and sailed calmly on.

Parents

Paul Durcan

A child's face is a drowned face:
Her parents stare down at her asleep
Estranged from her by a sea:
She is under the sea
And they are above the sea:
If she looked up she would see them
As if locked out of their own home,
Their mouths open
And their foreheads furrowed:
Pursed-up orifices of fearful fish
And their big ears like fins behind glass:
And in her sleep she is calling out to them
 Father, Father
 Mother, Mother
But they cannot hear her:
She is inside the sea
And they are outside the sea:
And, through the night, stranded, they stare
At the drowned, drowned face of their child.

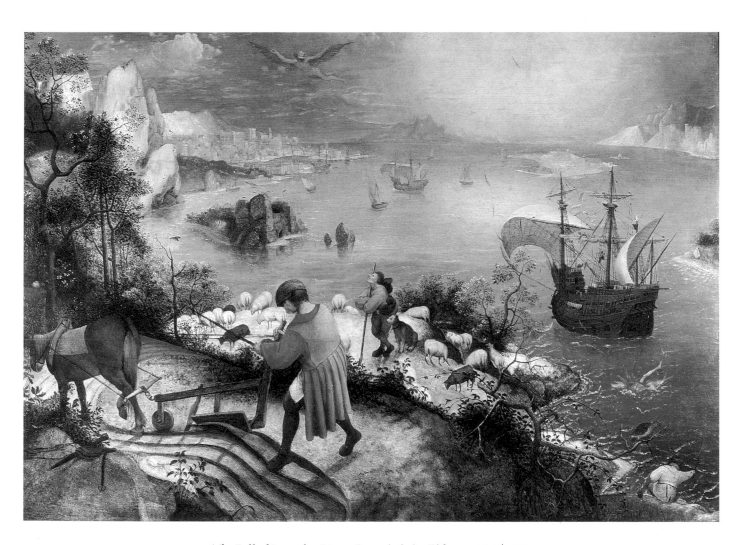

The Fall of Icarus by Pieter Brueghel the Elder. c. 1554–55.
Panel painting transferred to canvas, 29′ × 44′ ⅛″. Institut
Royal du Patrimoine Artistique, Belgium

LE TORO ESPAGNOL

Lament

Dylan Thomas

When I was a windy boy and a bit
And the black spit of the chapel fold,
(Sighed the old ram rod, dying of women),
I tiptoed shy in the gooseberry wood,
The rude owl cried like a telltale tit,
I skipped in a blush as the big girls rolled
Ninepin down on the donkeys' common,
And on seesaw sunday nights I wooed
Whoever I would with my wicked eyes,
The whole of the moon I could love and leave
All the green leaved little weddings' wives
In the coal black bush and let them grieve.

When I was a gusty man and a half
And the black beast of the beetles' pews,
(Sighed the old ram rod, dying of bitches),
Not a boy and a bit in the wick-
Dipping moon and drunk as a new dropped calf,
I whistled all night in the twisted flues,
Midwives grew in the midnight ditches,
And the sizzling beds of the town cried, Quick!—
Whenever I dove in a breast high shoal,
Wherever I ramped in the clover quilts,
Whatsoever I did in the coal-
Black night, I left my quivering prints.

When I was a man you could call a man
And the black cross of the holy house,
(Sighed the old ram rod, dying of welcome),
Brandy and ripe in my bright, bass prime,
No springtailed tom in the red hot town
With every simmering woman his mouse
But a hillocky bull in the swelter
Of summer come in his great good time
To the sultry, biding herds, I said,
Oh, time enough when the blood creeps cold,
And I lie down but to sleep in bed,
For my sulking, skulking, coal black soul!

When I was a half of the man I was
And serve me right as the preachers warn,
(Sighed the old ram rod, dying of downfall),
No flailing calf or cat in a flame
Or hickory bull in milky grass
But a black sheep with a crumpled horn,
At last the soul from its foul mousehole
Slung pouting out when the limp time came;
And I gave my soul a blind, slashed eye,
Gristle and rind, and a roarers' life,
And I shoved it into the coal black sky
To find a woman's soul for a wife.

Now I am a man no more no more
And a black reward for a roaring life,
(Sighed the old ram rod, dying of strangers),
Tidy and cursed in my dove cooed room
I lie down thin and hear the good bells jaw—
For, oh, my soul found a sunday wife
In the coal black sky and she bore angels!
Harpies around me out of her womb!
Chastity prays for me, piety sings,
Innocence sweetens my last black breath,
Modesty hides my thighs in her wings,
And all the deadly virtues plague my death!

Le Toro Espagnol by Pablo Picasso. 1942. Etching with
aquatint. Plate 4 from *Histoire Naturelle (Textes de
Buffon)* by Georges Louis Leclerc, Comte de Buffon
(Paris: Martin Fabiani, 1942). Arents Collections,
The New York Public Library, Astor, Lenox and
Tilden Foundations

All That Stuff Is Bull, Bull, Bull!
from *Cat on a Hot Tin Roof*
Tennessee Williams

BRICK: You feel better, Big Daddy?

BIG DADDY: Better? Hell! I can breathe!—All of my life I been like a doubled up fist....

 [*He pours a drink.*]

—Poundin', smashin', drivin'!—now I'm going to loosen these doubled-up hands and touch things *easy* with them....

 [*He spreads his hands as if caressing the air.*]

You know what I'm contemplating?

BRICK [*vaguely*]: No, sir. What are you contemplating?

BIG DADDY: Ha ha!—*Pleasure!*—pleasure with *women!*

 [*Brick's smile fades a little but lingers.*]

—Yes, boy. I'll tell you something that you might not guess. I still have desire for women and this is my sixty-fifth birthday.

BRICK: I think that's mighty remarkable, Big Daddy.

BIG DADDY: Remarkable?

BRICK: *Admirable*, Big Daddy.

BIG DADDY: You're damn right it is, remarkable and admirable both. I realize now that I never had me enough. I let many chances slip by because of scruples about it, scruples, convention—crap.... All that stuff is bull, bull, bull!—It took the shadow of death to make me see it. Now that shadow's lifted, I'm going to cut loose and have, what is it they call it, have me a—ball!

BRICK: A ball, huh?

BIG DADDY: That's right, a ball, a ball! Hell!—I slept with Big Mama till, let's see, five years ago, till I was sixty and she was fifty-eight, and never even liked her, never did!

Tennessee Williams in New York City. Photograph by W. Eugene Smith. 1947. *Life* Magazine © Time Warner

King of the World

O. B. Hardison, Jr.

I have become what I am.
There is now nothing in me that is not what I am.
All my roads lead to me.
I did not expect this to happen.

If I were an oak tree,
My leaves would be children,
Everything I love would be branches,
My enemies would be caterpillars,
My roots would be fastened deep in red clay.
You might then be, say, a bird. Something shining with
 impossible colors.
I would hold out my branches for you to roost in.
I would grow leaves to shade you.
I would give you my enemies to eat.
My roots would tremble with your singing.

If I were a building, I would have a baroque facade.
My windows would all be clean.
I would have a fountain—
Maybe *The Rape of Europa*—
And children would drink that water.
My walls would have mosaics, my floors *opus Alexandrinum*,
On my ceiling, the apotheosis of Marie Antoinette.
Your word for me would be house.

If I were the shore, every bay would have flags
To celebrate the powers of the sea.
My sand would be at your feet,
I would keep your seashells—
Tulips, razor clams, drills, olives, wentletraps—
For children on summer days.
At night your tide would cover me.
As we mingled, I would say:

Thank you, mother moon;
Thank you, father sun;
Thank you, thank you, thank you.

Every road meanders away from the center.
They all, in one way or another, go past your door.
Drive your triumphant car down any of them.
I will welcome you when you arrive.

The Colossus by Francisco Goya. 1808–12. Oil on canvas,
45⅝ × 39½". The Prado Museum, Madrid

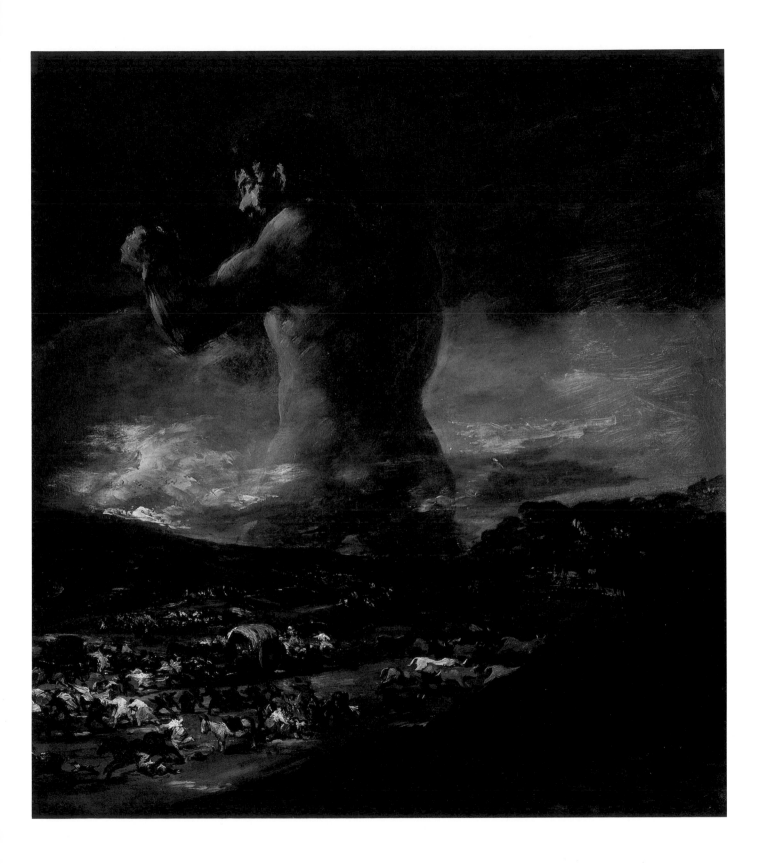

137

Oedipus Complex
from *Oedipus Rex*

Sophocles

Children, where are you?
Come quickly to my hands: they are your brother's—
Hands that have brought your father's once clear eyes
To this way of seeing—
 Ah dearest ones,
I had neither sight nor knowledge then, your father
By the woman who was the source of his own life!
And I weep for you—having no strength to see you—,
I weep for you when I think of the bitterness
That men will visit upon you all your lives.
What homes, what festivals can you attend
Without being forced to depart again in tears?
And when you come to marriageable age,
Where is the man, my daughters, who would dare
Risk the bane that lies on all my children?
Is there any evil wanting? Your father killed
His father; sowed the womb of her who bore him;
Engendered you at the fount of his own existence!
That is what they will say of you.

 Then, whom
Can you ever marry? There are no bridegrooms for you,
And your lives must wither away in sterile dreaming.

O Creon, son of Menoikeus!
You are the only father my daughters have,
Since we, their parents, are both of us gone for ever.
They are your own blood: you will not let them
Fall into beggary and loneliness;
You will keep them from the miseries that are mine!
Take pity on them; see, they are only children,
Friendless except for you. Promise me this,
Great Prince, and give me your hand in token of it.
 [CREON *clasps his right hand*]

Children:
I could say much, if you could understand me,
But as it is, I have only this prayer for you:
Live where you can, be as happy as you can—
Happier, please God, than God has made your father!

Statue of a Youth: The Kritios Boy. 480–470 B.C.
Acropolis Museum, Athens

my father moved through dooms of love

e.e. cummings

my father moved through dooms of love
through sames of am through haves of give,
singing each morning out of each night
my father moved through depths of height

this motionless forgetful where
turned at his glance to shining here;
that if(so timid air is firm)
under his eyes would stir and squirm

newly as from unburied which
floats the first who,his april touch
drove sleeping selves to swarm their fates
woke dreamers to their ghostly roots

and should some why completely weep
my father's fingers brought her sleep:
vainly no smallest voice might cry
for he could feel the mountains grow.

Lifting the valleys of the sea
my father moved through griefs of joy;
praising a forehead called the moon
singing desire into begin

joy was his song and joy so pure
a heart of star by him could steer
and pure so now and now so yes
the wrists of twilight would rejoice

keen as midsummer's keen beyond
conceiving mind of sun will stand,
so strictly(over utmost him
so hugely)stood my father's dream

his flesh was flesh his blood was blood:
no hungry man but wished him food;
no cripple wouldn't creep one mile
uphill to only see him smile.

Scorning the pomp of must and shall
my father moved through dooms of feel;
his anger was as right as rain
his pity was as green as grain

septembering arms of year extend
less humbly wealth to foe and friend
than he to foolish and to wise
offered immeasurable is

proudly and(by octobering flame
beckoned)as earth will downward climb,
so naked for immortal work
his shoulders marched against the dark

his sorrow was as true as bread:
no liar looked him in the head;
if every friend became his foe
he'd laugh and build a world with snow.

My father moved through theys of we,
singing each new leaf out of each tree
(and every child was sure that spring
danced when she heard my father sing)

then let men kill which cannot share,
let blood and flesh be mud and mire,
scheming imagine,passion willed,
freedom a drug that's bought and sold

giving to steal and cruel kind,
a heart to fear,to doubt a mind,
to differ a disease of same,
conform the pinnacle of am

though dull were all we taste as bright,
bitter all utterly things sweet,
maggoty minus and dumb death
all we inherit,all bequeath

and nothing quite so least as truth
—i say though hate were why men breathe—
because my father lived his soul
love is the whole and more than all

Self-Portrait by Edward
Estlin Cummings ("e.e.
cummings"). 1958. Oil
on canvas, 20 × 15″.
National Portrait
Gallery, Smithsonian
Institution,
Washington, D.C.

142

Do Not Go Gentle into That Good Night

Dylan Thomas

Do not go gentle into that good night,
Old age should burn and rave at close of day;
Rage, rage against the dying of the light.

Though wise men at their end know dark is right,
Because their words had forked no lightning they
Do not go gentle into that good night.

Good men, the last wave by, crying how bright
Their frail deeds might have danced in a green bay,
Rage, rage against the dying of the light.

Wild men who caught and sang the sun in flight,
And learn, too late, they grieved it on its way,
Do not go gentle into that good night.

Grave men, near death, who see with blinding sight
Blind eyes could blaze like meteors and be gay,
Rage, rage against the dying of the light.

And you, my father, there on the sad height,
Curse, bless, me now with your fierce tears, I pray.
Do not go gentle into that good night.
Rage, rage against the dying of the light.

The Forest by Alberto Giacometti. 1950. Painted bronze, 22 × 24 × 19¼".
National Gallery of Art, Washington, D.C. Gift of Enid A. Haupt

A Pact

Ezra Pound

I make a pact with you, Walt Whitman—
I have detested you long enough.
I come to you as a grown child
Who has had a pig-headed father;
I am old enough now to make friends.
It was you that broke the new wood,
Now is a time for carving.
We have one sap and one root—
Let there be commerce between us.

Ezra Pound by Alvin
Langdon Coburn. 1913.
Gelatin silver print.
George Eastman House,
Rochester, New York

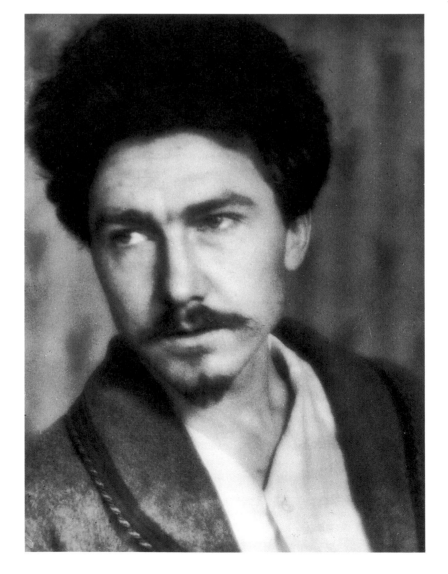

The Negro Speaks of Rivers

Langston Hughes

I've known rivers:
I've known rivers ancient as the world and older than the flow of human
 blood in human veins.

My soul has grown deep like the rivers.

I bathed in the Euphrates when dawns were young.
I built my hut near the Congo and it lulled me to sleep.

I looked upon the Nile and raised the pyramids above it.
I heard the singing of the Mississippi when Abe Lincoln went down
 to New Orleans, and I've seen its muddy bosom turn all golden in
 the sunset.

I've known rivers:
Ancient, dusky rivers.

My soul has grown deep like the rivers.

*Langston Hughes
(1902–1967)* by
Edward Weston. 1932.
Gelatin silver print,
9⁹⁄₁₆ × 7⅝". National
Portrait Gallery,
Smithsonian
Institution,
Washington, D.C.

Late Poem to My Father

Sharon Olds

Suddenly I thought of you
as a child in that house, the unlit rooms
and the hot fireplace with the man in front of it,
silent. You moved through the heavy air
in your physical beauty, a boy of seven,
helpless, smart, there were things the man
did near you, and he was your father,
the mold by which you were made. Down in the
cellar, the barrels of sweet apples,
picked at their peak from the tree, rotted and
rotted, and past the cellar door
the creek ran and ran, and something was
not given to you, or something was
taken from you that you were born with, so that
even at 30 and 40 you set the
oily medicine to your lips
every night, the poison to help you
drop down unconscious. I always thought the
point was what you did to us
as a grown man, but then I remembered that
child being formed in front of the fire, the
tiny bones inside his soul
twisted in greenstick fractures, the small
tendons that hold the heart in place
snapped. And what they did to you
you did not do to me. When I love you now,
I like to think I am giving my love
directly to that boy in the fiery room,
as if it could reach him in time.

David by Giacomo Manzú. Date unknown. Bronze, unique cast, 15¼ × 16 × 15¼". San Francisco Museum of Modern Art, California. Anonymous Gift

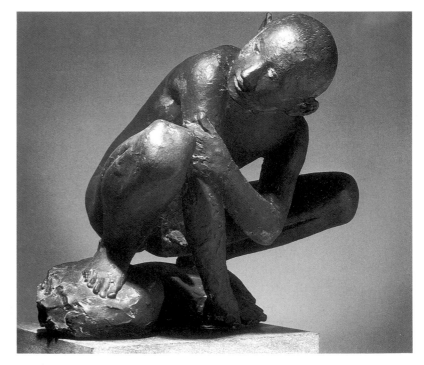

Of My Father's Cancer and His Dreams

Jimmy Carter

With those who love him near his bed
seldom speaking any more,
he lies too weak to raise his head
but dreams from time to time.
In one, he says, he sees his wife,
so proud in her white uniform.
with other nurses, trooping by,
their girlish voices aimed to charm
the young men lounging there.
Then her eyes met his and held.
A country courtship had begun.
They've been together thirty years.

Now, she watches over him
as she tries to hide her tears.
All his children are at home
but wonder what they ought to say
or do, either when he's awake
or when he seem to fade away.
They can't always be on guard,
and sometimes, if his mind is clear
he can grasp a whispered phrase
never meant for him to hear:
"He just seems weaker all the time."
"I don't know what else to cook.
He can't keep down anything."
He hears the knocking on the door,
voices of his friends who bring
a special cake or fresh-killed quail.
They mumble out some words of love,
then ask quietly how he feels,
and go back to spread the word:
"They say he may have weakened some."

He'll soon give up on the rising pain
and crave the needle that will numb
his knowledge of a passing world,
and bring the consummating sleep
he knows will come.

Jimmy Carter (James Earl, Jr.) by Rosalind Solomon.
1976. Gelatin siver print, 17 13/16 × 13 9/16".
National Portrait Gallery, Smithsonian Institution,
Washington, D.C.

Biographical Notes on Artists and Writers

Following are brief biographical notes about the writers and artists whose work appears in this book. Every effort has been made to achieve accuracy, but in some cases two or more sources gave different information about such matters as date or place of birth.

Adams, Henry Brooks (1838–1918). American man of letters, descendant of presidents, whose thoughtful and enduring books include novels, cultural studies, U.S. histories, and his modest autobiography, *The Education of Henry Adams* (1918).

Al-Bayati, Abdul Wahab (born 1926). Arab poet, born in Iraq, whose bittersweet lyrics were virtually unknown to the English-speaking world before a volume of translations, *Love, Death & Exile*, was published in 1990.

Auden, W. H. (1907–1973). British poet and playwright who became a U.S. citizen in 1946, won the Pulitzer Prize in 1948, and gave "The Age of Anxiety" its name, but saw beyond that a broader spectrum of man's weaknesses and triumphs.

Balzac, Honoré de (1799–1850). French author and social activist, larger than life and most of his compatriots, who published more than forty volumes of very lively fiction, drama, and other writings about the human comedy and human tragedy.

Bartlett, Jennifer (Losch) (born 1941). American artist, associated with the figurative "New Imagists" of the 1970s and 1980s, who paints on canvas or steel, sometimes producing dozens of slightly different versions of the same picture.

Bedell, Grace (1848–1936). American who wrote a persuasive letter to Abraham Lincoln when she was eleven years old; her father was a prominent Republican in New York State, but her brothers became Democrats.

Beerbohm, Sir Max (1872–1956). English satirist, caricaturist, and theater critic, sometimes called "The Incomparable Max," whose graphic works include *The Poet's Corner* (1904) and *Rossetti and His Circle* (1922).

Bishop, Elizabeth (1911–1979). American poet, translator, lecturer; awarded the Pulitzer Prize in 1956, the National Book Award in 1970, and many other distinctions.

Bottoms, David (born 1949). American writer who has published several books of plainspoken, earthy but not earthbound poetry, including *Easter Weekend* (1991), and a novel, *Any Cold Jordan* (1987).

Bowen, Elizabeth (1899–1973). Irish author, translator whose beautifully crafted short stories and novels, beginning with *Encounters* (1923) and *The Hotel* (1927), are widely enjoyed and admired.

Brooks, Gwendolyn (born 1917). Highly acclaimed and much-loved poet who has won numerous honors, such as the Pulitzer Prize (1950); the first African-American writer to achieve great popularity in the U.S.; books include *Selected Poems* (1963) and many others.

Brueghel, Pieter, the Elder (c. 1525–1569). Netherlandish artist whose greatest paintings include *Hunters in the Snow* (c. 1565–70) and other absorbing scenes of rural life, as well as works of allegorical or mythological significance.

Burchfield, Charles (1893–1967). American painter who returned to his first love, the depiction of nature in fantastic watercolors, following a decade of much more down-to-reality "Depression art" during the 1930s.

Cameron, Julia Margaret (1815–1879). British traveler and scholar who took up photography in 1863, specializing in poetic images of ethereal maidens and more mundane portraits of older people.

Campbell, Joseph (1904–1987). American scholar and lecturer, author of *The Hero with a Thousand Faces* (1949) and several other trendsetting books, who attracted a large new audience to mythology and folklore.

Capa, Robert (né André Friedmann) (1913–1954). European photographer, later a U.S. citizen, whose close-to-the-action pictures of bloodshed and heroism during the Spanish Civil War and World War II were featured in *Life, Collier's,* and other periodicals.

Carter, Jimmy (James Earl, Jr.) (born 1924). American political leader, 39th president of the U.S. (1977–1981), who continues to lead the way in public service as a private citizen.

Casey, John (born 1939). American writer, former professor at the University of Virginia, whose honors include a National Book Award for his novel *Spartina* (1989) and a major grant from the American Academy in Rome.

Cassatt, Katherine (Kelso Johnston) (1816–1895). American who often lived abroad; mother of the artist Mary Cassatt and of Alexander Cassatt (1839–1906), who appears with his son Robert (1873–1944) in one of many charming family portraits.

Cassatt, Mary (1844–1926). American artist who worked mostly in Paris, frequently portraying her relatives and visitors; she studied and used Impressionist techniques at first, but later developed her own distinctive style in highly praised paintings and prints.

Chagall, Marc (1887–1985). Early modern artist, born in Russia, whose vivid, often whimsical, sometimes sober work reflects his childhood there and his Jewish heritage, as well as the romantic highlights of his later life in France.

Chang, Diana (born 1934). Chinese-American writer, lecturer, painter; her publications include several novels, starting with *The Frontiers of Love* (1956), as well as poems and short stories in numerous magazines and anthologies.

Chase, William Merritt (1849–1916). American landscape artist, portraitist, teacher, influential in his day, whose paintings are stylish and lively—occasionally stunning—but definitely not "modern," although he was well aware of these trends.

Cheever, John (1912–1982). American author whose popular short stories and novels, most notably *The Wapshot Chronicle* (1957), have explored various answers to the question of what is the good life.

Chesterfield, Lord (1694–1773). The name by which an English nobleman, Philip Dormer Stanhope, 4th Earl, became famous as the author of letters of parental advice (1748) to his natural son, also named Philip.

Ciardi, John (1916–1986). American poet, editor, and lecturer who took the time to encourage younger writers; his lucid translations of Dante have found a lasting place in world literature.

Clemens, Olivia Susan (1872–1894). American biographer of Samuel Clemens (Mark Twain) who tried her father's patience while she lived but broke his heart when she died.

Coburn, Alvin Langdon (1882–1966). American photographer, founding member of the Photo-Secession group, recognized as a pioneer of abstraction; met Ezra Pound and other modernists after moving to England in 1912.

Cofer, Judith Ortiz (born 1952). American author and teacher who moved from Puerto Rico to Georgia; her thought-provoking poems can be found in *Peregrina* (1986) and in the collection *Triple Crown* (1987), as well as recent periodicals.

Coles, Robert (born 1929). American psychiatrist, Harvard professor, winner of countless honors and awards including the Pulitzer Prize; his numerous publications include some insightful books about the political, moral, and spiritual life of children.

cummings, e.e. (Edward Estlin) (1894–1962). American writer, occasional painter, whose way with words is sometimes hard to follow but usually worth the effort; his *Complete Poems* (1972) display great talent and depth of feeling.

Darwin, Charles (Robert) (1809–1882). English natural scientist and philosopher who studied evolution and natural selection, became one of the most famous and controversial figures of modern times.

David, Gérard (c. 1460–1523). Netherlandish painter whose religious pictures, such as *The Marriage at Cana* (c. 1503), are viewed today as well executed and devout but perhaps too stiff and solemn.

Day, Clarence (Shepard) (Jr.) (1874–1935). American author whose best-known book, *Life with Father* (1935), became a best-seller after his death, later giving rise to a Broadway play and a Hollywood movie.

Day-Lewis, Cecil (1904–1972). British poet laureate whose *Complete Poems* (1992) curiously omit the touching lines he wrote on the birth of his son Daniel, the actor, star of *In the Name of the Father* and other films.

Degas, (Hilaire Germain) Edgar (1834–1917). French artist, best known for pictures and sculptures of ballet dancers, who

frequently observed people at work and play in order to portray them with authentic expressions and movements.

de Andrade, Carlos Drummond (1902–1987). Brazilian poet whose sensitive, realistic writing has attracted new U.S. readers since the publication in English of *Traveling in the Family: Selected Poems* (1987).

Dickens, Charles (1812–1870). World-famous author whose best novels, including *Great Expectations* (1861) and *Oliver Twist* (1867), are suspenseful tales of individuals caught up in the crosscurrents of social class and social conflict in 19th-century England.

Dickey, James (born 1923). American poet and novelist, author of best-sellers *Deliverance* (1970) and *To the White Sea* (1993); professor of English and writer-in-residence at the University of South Carolina.

Diebenkorn, Richard (1922–1993). Influential American artist who won early fame for his abstract paintings but later inspired a return to figurative work in the San Francisco Bay area and elsewhere.

Durcan, Paul (born 1944). Irish poet who has traveled and given readings of his work throughout the world; books include *The Berlin Wall Café* (1985) and *Going Home to Russia* (1987).

Emanuel, James (born 1921). African-American poet and poetry reader whose recordings help to bring his poems alive; books include *The Treehouse* (1968) and *Panther Man* (1970).

Erwitt, Elliott (born 1928). American photographer who has captured special moments in the lives of ordinary and extraordinary people, including Kennedy, Khrushchev, Nixon, and others.

Felsenthal, Sandy. Contemporary American photographer whose work appears in *National Geographic* and other leading periodicals.

Finch, Ruby Devol (1804–1866). American folk artist who used watercolors and cut paper to produce small portraits of Massachusetts neighbors, as well as larger narrative scenes from the Parable of the Prodigal Son.

Fitzgerald, F. Scott (1896–1940). American author who sometimes wasted his gifts, died young, and was almost forgotten, but is now recognized as one of our finest novelists and short story writers; often wrote to or about his wife Zelda (1900–1948) and daughter "Scottie" (1921–1986).

Flaubert, Gustave (1821–1880). French author whose penetrating stories of his fictional heroine Emma Bovary and other outwardly respectable members of the bourgeoisie were intended to shock his readers, and did so.

Frank, Mary (born 1933). American artist, born in England, whose sculptures and monoprints—especially those of women—are full of mysterious movement and intense emotion.

Freud, Lucian (born 1922). British painter, grandson of Sigmund Freud, whose recent work has gone beyond the limits of conventional portraiture in characterizing his subjects with more subtlety and symbolic power than his earlier realism would allow.

Frost, Robert (1874–1963). One of America's most widely read and revered poets, a dedicated teacher as well; awarded the Pulitzer Prize in 1924, 1931, 1937, and 1943, among many other honors; Consultant in Poetry at the Library of Congress, 1958.

Gauguin, Paul (1848–1903). French Post-Impressionist artist who abandoned the social and esthetic conventions of his era to pursue a vision of primitive life in the South Seas, which he depicted in paintings and sculptures now world-famous.

Giacometti, Alberto (1901–1966). Swiss sculptor and painter best known for elongated, frail-looking figures in bronze, such as *Man Pointing* (1947) and *City Square* (1949), which have had a strong influence on contemporary work.

Gilbert, Sandra M. (born 1936). American author and university professor whose poetry books, including *Emily's Bread* (1984) and *Blood Pressure* (1988), have a distinctly feminist point of view.

Goings, Ralph (born 1928). American painter best known for precise photorealist pictures of automobiles and other objects he regards as modern society's icons of materialism.

Gomez, F. Ricardo. Nothing is known about this author, whose poem "Man's Pride" was published in the April 1968 isssue of *El Malcriado*, the journal of the United Farm Workers, but it is speculated that he was a migrant laborer himself.

Goya (y Lucientes), Francisco José de (1746–1828). Spanish artist who produced outstanding portraits, religious paintings, political scenes, and other works that stirred his contemporaries and influenced his successors.

Grass, Günter (Wilhelm) (born 1927). German writer whose publications include a highly successful early novel, *The Tin Drum* (1959); less familiar are his more recent achievements as a graphic artist and sculptor.

Gregg, Linda (born 1942). American poet and teacher whose awards include a Guggenheim Fellowship; author of *The Sacraments of Desire* (1991) and other books in which her strong talents are evident.

Hall, Donald (born 1928). American author, critic, editor, and influential teacher of poetry; has published *Kicking the Leaves* (1978) and *The Happy Man* (1986), among many other books.

Haozous, Bob (born 1943). Native American sculptor whose sometimes satiric, sometimes monumental work in steel has caused much comment in the Southwestern U.S. and elsewhere.

Hardison, O. B., Jr. (1928–1990). American who was truly a man of letters, equally at home in poetry or prose, reading or writing, learning or teaching; books include *Disappearing Through the Skylight: Culture and Technology in the Twentieth Century* (1989).

Hayden, Robert (1913–1980). American poet and university professor whose books, including *Selected Poems* (1966) and *Angle of Ascent* (1975), have contributed to the growing recognition of African-American writers.

Hemingway, Ernest (1899–1961). American author, winner of the Pulitzer and Nobel prizes, who explored the difficulties of manhood in *The Sun Also Rises* (1926), *A Farewell to Arms* (1929), and other highly regarded novels and short stories.

Henson, Lance (born 1944). American author whose books, starting with *Keepers of Arrows: Poems for the Cheyenne* (1972), have helped people to understand the Native American cultures of the Southwestern U.S.

Hockney, David (born 1937). British artist who moved to the U.S. in the 1960s; has achieved both critical success and wide popularity with his bold, innovative drawings, paintings, photographic collages, and designs for theatrical sets.

Holmes, John (1904–1962). American poet, editor, professor at Tufts College who succeeded in teaching others, such as Anne Sexton, but whose own well-wrought poetry is generally neglected now.

Homer, Winslow (1836–1910). American magazine illustrator who became a powerful, original painter; his work ranges in subject and mood from the Civil War and the rugged seacoast to pastoral scenes of children at play.

Hughes, (James) Langston (1902–1967). Considered the leading African-American poet of his period; starting with *The Dream Keeper* (1932), he was a prolific writer who opened the doors of opportunity for generations of authors coming after him.

Hunt, William Morris (1824–1879). American painter who studied with the Barbizon School of landscape artists in France; later practiced and taught their approach in the U.S., where he became famous and influential for a time.

Ignatius of Loyola, Saint (Iñigo de Oñaz y Loyola) (1491–1556). Spanish priest, founder of the Society of Jesus, dedicated to both the spiritual and material well-being of mankind, especially the poor.

James, Henry (1843–1916). American writer who moved to England in 1876; his intricate novels of high society, including *The Portrait of a Lady* (1881), *The Bostonians* (1886), and *The Ambassadors* (1903), are widely read and highly praised today.

Johnson, Eastman (1824–1906). American artist whose genre paintings, starting with *Old Kentucky Home* (1859), made him famous, but whose insightful and skillful portraiture sustained him in later years.

Jones, LeRoi (name later changed to Baraka, Imamu Amiri) (born 1934). American writer and college professor whose books, starting with *Black Poetry 1961–1967*, have strongly expressed the need for individual and social change.

Joyce, James (1882–1941). Irish writer whose life and work are splendidly interwoven in his masterpiece, *Ulysses* (1922), but knottier and more tangled in the enigmatic *Finnegans Wake* (1939).

Jung, C. G. (1875–1961). Swiss psychiatrist, at one time Sigmund Freud's heir apparent, who broke away because of differ-

ing views on sexuality, dreams, myths, the role of the father, and other issues.

Karsh, Yousuf (born 1908). Canadian photographer, born in Armenia, who has won awards and honors for his work, which includes insightful portraits of Einstein, O'Keeffe, Picasso, and Queen Elizabeth II, among others.

Kennelly, Brendan (born 1936). Irish poet, dramatist, translator, editor, author of more than twenty books of hand-quarried narrative and lyric verse; also professor of modern literature at Trinity College, Dublin.

Kerouac, Jack (Jean-Louis Lebrid de) (1922–1969). American author, wanderer, onetime football star, who gave the "Beat Generation" its name and several of its best books, including *On the Road* (1957) and *The Dharma Bums* (1958).

Kiefer, Anselm (born 1945). German painter whose large and sometimes threatening landscapes, such as *Scorched Earth* (1974), are thought to express his views about his country's troubled past.

Kinsey, Darius (1869–1945). American photographer who produced thousands of images of logging and other industries in the rugged Northwestern U.S.; considered a "near genius" for his technical skill in capturing fleeting subjects.

Klee, Paul (1879–1940). Swiss-born artist who lived and taught mostly in Germany, producing a wide variety of original and influential art that he compared to the branching and blossoming of a tree.

Klimt, Gustav (1862–1918). Austrian painter and designer who combined the simplicity of natural beauty with the richness of elaborate ornamentation in his unmistakable pictures such as *The Kiss* (c. 1911).

Kollwitz, Käthe (1867–1945). German graphic artist and sculptor whose work—now receiving more recognition and praise—is sincerely concerned with human suffering and the need for love.

Kroll, Judith (born c. 1940). American poet who has spent many years in India, absorbing the cultural and spiritual influences of that country and translating its mystic 12th-century lyrics into English.

La Farge, Mabel Hooper (1875–1944). American artist whose uncle, Henry Adams, included her reminiscences in a posthumously published book, *Letters to a Niece* (1920).

Lardner, Ring (1885–1933). American reporter, sportswriter, syndicated columnist, still admired for his funny, seemingly unsophisticated fiction, including *You Know Me, Al* (1916) and *How to Write Short Stories (With Samples)* (1924).

Larkin, Mary Ann (born 1945). American poet and poetry reader, now a teacher of writing at Howard University, whose publications include *The Coil of the Skin* (1982).

Lawrence, D. H. (David Herbert) (1885–1930). British author and artist who became famous and infamous for the sexual explicitness of his writing in *Lady Chatterley's Lover* (1928) and earlier works.

Lawrence, Jacob (born 1917). Highly regarded American artist whose psychologically and pictorially complex paintings explore various historical and contemporary themes relating to the lives of African Americans.

Lennon, John Ono (1940–1980). British composer, lyricist, performer, and writer who moved to New York and became a U.S. citizen but will always be remembered as one of the leaders of The Beatles during the 1960s.

Longfellow, Henry Wadsworth (1807–1882). American poet who taught at Harvard University and created a new mythology with his rhythmic, easily memorizable tales of Evangeline, Hiawatha, Paul Revere, the village blacksmith, and other figures.

Lowell, James Russell (1819–1891). American man of letters remembered mostly for his patriotic poetry; also a U.S. diplomat and Harvard professor of languages.

Manzù, Giacomo (1908–1991). Italian sculptor, best known for the bronze doors of St. Peter's, Rome, and other religious work which is traditional in style yet modern in feeling.

Michelangelo (di Lodovico Buonarroti Simoni) (1475–1564). Italian Renaissance painter, sculptor, architect, and poet, whose unsurpassed works of art include the ceiling of the Vatican's Sistine Chapel, completed almost single-handedly in four years (1508–12).

Momaday, N. Scott (born 1934). American writer, professor at Stanford University, winner of the Pulitzer Prize for fiction (1969) and other honors for his stories and poems about Native Americans.

Moore, Henry (1898–1986). British artist whose massive, abstract sculptures of people and animals are rooted in his life-long study of their realistic forms, although his interpretation of reality is highly imaginative.

Murphy, Gerald (1888–1964). Socially prominent American who used his creative talents variously in business, art, and living well, and with his wife Sara "invented" part of the French Riviera as a summer resort to amuse Picasso, the Fitzgeralds, and other celebrities of the 1920s.

Nash, Ogden (1902–1971). American writer and humorist who produced so many volumes of poems that he made it seem easy; books include *The Bad Parents' Garden of Verse* (1936) and *You Can't Get There from Here* (1957).

Neri, Manuel (born 1930). American sculptor, professor of art at the University of California, Davis, increasingly well regarded for his sensuous, innovative work in plaster and more recently in marble.

Neruda, Pablo (Ricardo Eliecer Neftali Reyes y Basoalto) (1904–1973). Chilean poet and diplomat who won the Nobel Prize in 1973; books include *One Hundred Love Poems* (1986) and other modern classics.

Nissenson, Hugh (born 1933). American writer and lecturer known originally for short stories set in Eastern Europe and Israel; his later novel of the U.S. frontier, *The Tree of Life* (1985), has been highly praised and translated into six languages.

Noche. An Apache scout for the U.S. Army in the late 19th century, whose eloquent letter about the harsh treatment of Native American people has been preserved in the archives of the Senate.

Nordhaus, Jean (born 1939). American poet who helps other writers find a publisher or an audience for readings; her own books include *A Bracelet of Lies* (1987).

Okada, John (1923–1971). Japanese-American author whose published works include the novel *No-No Boy* (1957), in which the difficulties of growing up are compounded by cultural problems.

Olds, Sharon (born 1942). American writer, teacher, whose powerful yet gentle lyrics can be found in poetry recordings as well as in *The Dead and the Living* (1984), *The Gold Cell* (1987), and other books.

Ortiz, Simon J. (born 1941). Native American poet who frequently writes about members of his family or his tribe, the Acoma, and the ways in which traditions are passed along from generation to generation.

O'Sullivan, Timothy H. (c. 1840–1882). American photographer, early protégé of Mathew Brady, who later produced some of the most memorable images of the Civil War and the American frontier of the 1870s.

Parcell, James A. Contemporary American photographer who has worked on the staff of the *Washington Post* and other periodicals.

Picasso, Pablo (1881–1973). Creative genius born in Spain, lived mostly in France, produced a wealth of paintings, sculpture, graphics, and ceramics that teach us much about what is truly "modern" in modern art.

Plath, Sylvia (1932–1963). American poet, novelist, posthumously awarded the Pulitzer Prize in 1981, whose suicide cut short a tragic life and a profound creative gift.

Pound, Ezra (1885–1972). American man of letters who played an important part in the shaping of modern poetry, despite his personal problems; books include *Personae* (1909), *The Pisan Cantos* (1948), and *Selected Poems* (1975).

Reynolds, Sir Joshua (1723–1792). English artist who achieved great affluence and influence through portrait commissions from George III and others; later produced mythological and allegorical paintings that were also well received.

Roberts, Elizabeth Madox (1886–1941). American author whose straightforward poems and short stories about family life were widely read in the 1920s and 1930s.

Rockwell, Norman (1894–1978). Popular American painter and illustrator who portrayed the people of the U.S. in loving detail for *The Saturday Evening Post* and other magazines.

Rodin, Auguste (1840–1917). French artist who raised sculpture to new heights of human beauty and passion in world-renowned works such as *The Thinker* (1879–89), *The Kiss* (1886), and *Monument to Balzac* (1897–98).

Rubens, (Sir) Peter Paul (1577–1640). Hightly talented, influential Flemish artist whose brilliant, heroic paintings brought him so many new commissions that he could hardly keep up with his increasing success.

Saint-Gaudens, Augustus (1848–1907). American sculptor of superb monuments such as *The Robert Gould Shaw Memorial* (1884–97) in Boston and outstanding private commissions such as the memorial to Marian Hooper Adams (1891) in Washington.

Sargent, John Singer (1856–1925). American painter who moved to London and used his remarkable skills to win fame and fortune with flattering portraits of fashionable people, although he occasionally produced larger masterpieces such as *El Jaleo* (1882).

Schachtner, Bruno (born 1941). German artist who focuses on the social and psychological conditions in his country during World War II; his work is being increasingly recognized in the U.S. as well as in Europe.

Sexton, Anne (1928–1974). American poet, winner of the Pulitzer Prize in 1967, whose troubled life, relentless honesty, and great creative powers are abundantly evident in her posthumously published *Complete Poems* (1981).

Shakespeare, William (1564–1616). English playwright, actor, poet—also a considerable historian, philosopher, psychologist—whose identity is sometimes disputed but whose talent is not.

Shaw, George Bernard (1856–1950). Irish writer whose keen interest in social problems is sharply, often amusingly dramatized in his plays, such as *Major Barbara* (1905), *Pygmalion* (1912), and *Back to Methusaleh* (1918–20).

Sherbell, Rhoda (born 1933). American sculptor, art consultant, teacher, whose award-winning work includes the monumental *William and Marguerite Zorach* (1964), commissioned by the Smithsonian.

Simpson, Mona (Elizabeth) (born 1957). American writer of great promise and considerable achievement; publications include two novels, *Anywhere But Here* (1986), which has been translated into fourteen languages, and *The Lost Father* (1992).

Smith, W. Eugene (1918–1978). American photographer who specialized in producing vivid "photographic essays," first seen in *Life* and other magazines, on large-scale subjects such as sports contests and the battlefields of World War II.

Solomon, Rosalind (born 1930). American photographer, known for candid portraits of her subjects, whose work can be seen in The Metropolitan Museum of Art, Eastman House, Musée de la Ville de Paris, and other major collections.

Sophocles (c. 495–406 B.C.). Greek playwright whose *Oedipus Rex* (or *King Oedipus*), *Electra*, *Oedipus at Colonos*, and other powerful dramas have stimulated modern psychoanalytic and feminist thought.

Sullivan, Charles (born 1933). American writer, editor, educator, whose poetry books include *The Lover in Winter* (1991) and *A Woman of a Certain Age* (1995).

Thomas, Dylan (1914–1953). Welsh writer whose superb poetry was unforgettably matched by his magnificent reading voice as he celebrated from firsthand experience the human struggle to live, love, and create.

Thurber, James (1894–1961). American author and cartoonist who found strange but still popular humor in the lives of men, women, pets; books include *The Thurber Album* (1952), *Thurber Country* (1953), and *Thurber's Dogs* (1955), among other favorites.

Tilghman, Christopher (born 1947). American writer and teacher who believes strongly in storytelling: "It's on the level of people and event and consquence where literature happens."

Toledo, Francisco (born 1940). Mexican painter, graphic artist, and sculptor, whose colorful, fanciful work is increasingly appreciated in the U.S. and Europe.

Traylor, Bill (1854–1947). American artist who began to draw at age eighty-five, producing "naive" narratives derived from his long life on an Alabama plantation, where he was born a slave.

Turgenev, Ivan (Sergeevich) (1818–1883). Russian writer who attempted to depict the timeless in the turbulent context of his own prerevolutionary times; *Fathers and Children* (or *Fathers and Sons*) (1862) is regarded as a masterpiece.

Twain, Mark (Samuel Langhorne Clemens) (1835–1910). American author, humorist who created his own folklore of boyhood in *The Adventures of Tom Sawyer* (1876), *The Adventures of Huckleberry Finn* (1885), and other timeless stories.

Uelsmann, Jerry (born 1934). American photographer who often produces multiple images in a single picture (by superimposing negatives in the printing process) and hopes to evoke multiple responses in the viewer.

van Gogh, Vincent (1853–1890). Dutch artist of the Post-Impressionist era whose paintings of everyday people, places, and things have enormous vitality and universal appeal.

Vuillard, Edouard (1868–1948). French painter whose pictures of home and family life, warm and richly detailed, were recently featured in a major U.S. exhibition of his work.

Warren, Robert Penn (1905–1989). American author, winner of three Pulitzer Prizes and numerous other awards, who blended personal, regional, and national history in more than thirty books, including *New and Selected Poems 1923–1985*.

Watson, James D. (born 1928). American scientist, now specializing in cancer research, who shared the Nobel Prize in medicine (1962) for discovering the "double helix" structure of the DNA molecule.

Watts, George Frederick (1817–1904). English painter and sculptor whose contemporaries considered his skillful portraits less significant than his later, allegorical paintings such as *Hope* (1886).

Weston, Edward (1886–1958). American photographer who carefully "previsualized" his pictures of people and objects, but would not manipulate the resulting negatives or prints in any way.

Wharton, Edith (Newbold Jones) (1862–1937). American writer whose insider stories of elite society, such as *The House of Mirth* (1905) and *The Age of Innocence* (1920), are increasingly popular with critics and the public.

Whistler, James Abbott McNeill (1834–1903). Energetic, disputatious American painter who did much to define the state of the art in works he produced while living abroad, such as the abstract and controversial *Nocturne in Black and Gold* (1874).

Whitman, Walt (1819–1892). American writer, broad of mind and great of heart, whose *Leaves of Grass*, published anonymously in 1855 and often revised thereafter, set new standards for the subjects and techniques of American poetry.

Wilbur, Richard (born 1921). American man of letters, recipient of many honors, including the Pulitzer Prize and the National Book Award, 1957; Poet Laureate and Consultant in Poetry at the Library of Congress, 1987–88.

Williams, Tennessee (1911–1983). American playwright, relentless in probing the complex emotions of his characters, who won Pulitzer Prizes for *A Streetcar Named Desire* (1947) and *Cat on a Hot Tin Roof* (1955).

Wood, Grant (1892–1942). American painter who gradually developed a distinctive and popular style, producing *American Gothic* (1930), *The Midnight Ride of Paul Revere* (1931), and other well-known pictures.

Wordsworth, William (1770–1850). Romantic, philosophical English writer, lyrical about the Lake Country but keenly interested in the French Revolution, who led his generation back to nature and became Poet Laureate in the process.

Wright, George Hand (1872–1951). American painter, illustrator, teacher, whose pictures help us to imagine small-town life in the U.S. as earlier generations saw it.

Wyeth, Andrew (born 1917). American painter who is perhaps too skillful; his finely detailed treatment of emotional subjects, as in *Christina's World* (1948), has appealed greatly to the public but not necessarily to the critics.

Wylie, Elinor (1885–1928). American writer whose social prominence and glamour have led some readers to overlook the fresh, crisp images and subtle ideas in her poetry and prose.

Yaroshenko, Nikolai Aleksandrovich (1846–1898). Russian artist who painted genre scenes but was most admired by his contemporaries for the profound understanding shown in his portraits of young people during an era of social upheaval.

Acknowledgments

Grateful acknowledgment is made for permission to reproduce the poems, songs, and excerpts from texts listed below by page number. All possible care has been taken to make full acknowledgment. If any errors have occurred, they will be corrected in subsequent editions, provided that written notification is sent to the publisher.

p. 12: From *The Lost Father* by Mona Simpson, Alfred A. Knopf, Inc., New York, 1991. Reprinted by permission of Random House, Inc.; p. 13: Paraphrase of PLAYBOY Magazine interview with John Lennon and Yoko Ono by David Sheff, September, 1980. Copyright 1981 by PLAYBOY; p. 14: "Time and My Father's Cousin" from *The Double Root* by John Holmes. Twayne Publishers, Inc., New York. Copyright 1950 by John Holmes. Reprinted by permission of Doris Holmes Eyges; p. 16: "Each Morning" (Section 4) from "Hymn For Lanie Poo" from the *LeRoi Jones/Amiri Baraka Reader*. Reprinted by permission of Sterling Lord Literistic, Inc. Copyright © 1991 by Amiri Baraka; p. 18: Reprinted with permission of Scribner, an imprint of Simon & Schuster. From *The Double Helix*, James D. Watson, © 1968 by James D. Watson; p. 19: From *Collected Poems* by Elinor Wylie. Copyright 1932 by Alfred A. Knopf, Inc., and renewed 1960 by Edwina C. Rubenstein. Reprinted by permission of Alfred A. Knopf, Inc.; p. 21: Campbell, Joseph, *The Hero with a Thousand Faces*, Bollingen Series XVII. Copyright © 1949 renewed 1976 by Princeton University Press; p. 22: From *Collected Stories* by Elizabeth Bowen. Copyright © 1981 by Curtis Brown Ltd., Literary Executors of the Estate of Elizabeth Bowen. Reprinted by permission of Alfred A. Knopf, Inc.; p. 24: From *The Journals of John Cheever*, Alfred A. Knopf, Inc., New York, 1991; Copyright 1990, 1991 by Mary Cheever, Susan Cheever, Benjamin Cheever and Frederico Cheever. Reproduced by permission of Random House, Inc.; p. 26: Excerpted from *Survival of the Spirit: Chiricahua Apaches in Captivity* by H. Henrietta Stockel (Reno: University of Nevada Press, 1993). Used by permission of the publisher; p. 27: From *ALMA* by Linda Gregg. Copyright © 1986 by Linda Gregg. Reprinted by permission of Random House, Inc.; p. 31: Excerpt from "In a Father's Place" from *In a Father's Place* by Christopher Tilghman. Copyright © 1990 by Christopher Tilghman. Reprinted by permission of Farrar, Straus & Giroux, Inc.; p. 32: Reprinted with the permission of Scribner, an imprint of Simon & Schuster, from *First and Last* by Ring Lardner. Copyright 1920 Curtis Publishing Company; copyright renewed 1948 Ellis A. Lardner; p. 33: Copyright © 1952 James

Thurber. Copyright © Helen Thurber and Rosemary A. Thurber. From *The Thurber Album*, published by Simon & Schuster; p. 36: Excerpt from *Mark Twain's Notebook* by Mark Twain. Copyright 1935 by The Mark Twain Company. Copyright renewed 1963 by Louise Paine Moore, reprinted by permission of HarperCollins Publishers, Inc.; p. 36: From *PAPA, An Intimate Biography of Mark Twain* by Susy Clemens, his daughter, Doubleday, 1985, copyright 1985 by The Mark Twain Foundation; p. 38: From *Keeper of Arrows*, Renaissance Press, 1972 by Lance Henson; p. 39: "A Record Stride" from *The Poetry of Robert Frost*. Copyright © 1969 by Henry Holt & Co., Inc. Reprinted by permission of Henry Holt and Co., Inc.; p. 41: "Family Portrait" by Carlos Drummond de Andrade, translated by Elizabeth Bishop, from *The Complete Poems 1927–1979* by Elizabeth Bishop. Copyright © 1979, 1983 by Alice Helen Methfessel. Reprinted by permission of Farrar, Straus & Giroux, Inc.; p. 42: From *Life With Father* by Clarence Day. Copyright 1935 by Clarence Day and renewed 1963 by Mrs. Katherine B. Day. Reprinted by permission of Alfred A. Knopf, Inc.; p. 44: From *Verses from 1929 On* by Ogden Nash. Copyright 1933, 1936 by Ogden Nash. Copyright © 1961 by Ogden Nash. By permission of Little, Brown and Company; p. 46: Permission to reprint "My Father's Song" given by author, Simon J. Ortiz; pp. 48–49: "Father's Story" from *Under the Tree* by Elizabeth Madox Roberts. Copyright 1922 by B. W. Huebsch, Inc., renewed 1950 by Ivor S. Roberts. Copyright 1930 by Viking Penguin, Inc., renewed © 1958 by Ivor S. Roberts. Used by permission of Viking Penguin a division of Penguin Books USA Inc.; p. 53: Copyright © 1983 by David Bottoms. Used by permission of Maria Carvainis Agency, Inc. All rights reserved; p. 54: Reprinted with the permission of Scribner, an imprint of Simon & Schuster, from *Ring Around the Bases: The Complete Baseball Stories of Ring Lardner*. Edited and with an introduction by Matthew J. Bruccoli. Copyright © 1992 Estate of Ring Lardner (First appeared in *The Saturday Evening Post*, April 23, 1932), one of six stories collected in *Lose with a Smile*, (New York, Scribner's, 1933); p. 56: Reprinted by permission of Bloodaxe Books, Ltd. From *A Time For Voices: Selected Poems 1960–1990* (Bloodaxe Books, 1990); pp. 56–57: Copyright © Mary Ann Larkin; p. 58: From *Spartina* by John Casey. Copyright © 1989 by John Casey. Reprinted by permission of Alfred A. Knopf, Inc.; pp. 60–61: Excerpt from *Sons and Lovers*, D. H. Lawrence, Penguin, 1913; p. 62: *The Collected Works of C. G. Jung*, trans. R. F. C. Hull, Bollingen Series XX. Vol. 4: *Freud and Psychoanalysis*, copyright © 1961, renewed

Index to Artists

Index to Writers